IMAGES
of America

LATTER-DAY SAINTS IN TUCSON

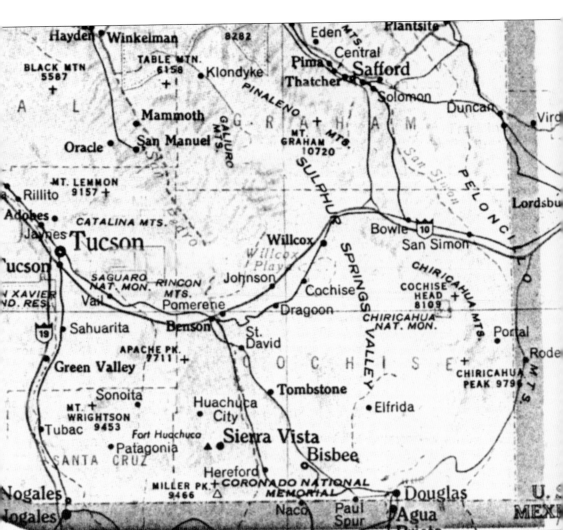

Latter-day Saint congregations in Tucson were originally formed in 1910 under the auspices of the California Mission. As geographer D.W. Meinig writes, "These urban Mormon groups [including those at Tucson] were originally formed and continue to be sustained in part by local rural migrants." Tucson Latter-day Saints came from Mexico, Douglas, St. David, the Gila Valley (Safford and Thatcher), and New Mexico. (*Map of Arizona, 1912*; author's collection.)

ON THE COVER: Friendship and a love of music brought together this band of Mormon women in December 1949. They are, from left to right, Eathel Busby (violin), Lucy Mortensen (guitar), Avez Goodman (accordion), and Clara Kimball (harmonica). Shirley Busby (electric Hawaiian guitar) is seen on the back, and the full photograph including Ethel Goodman (violin) is on page 121. The name of their band, MGBBK, represents their surnames. (Joyce McRae.)

IMAGES
of America

LATTER-DAY SAINTS
IN TUCSON

Catherine H. Ellis

ARCADIA
PUBLISHING

Copyright © 2013 by Catherine H. Ellis
ISBN 978-0-7385-9637-2

Published by Arcadia Publishing
Charleston, South Carolina

Printed in the United States of America

Library of Congress Control Number: 2012944490

For all general information, please contact Arcadia Publishing:
Telephone 843-853-2070
Fax 843-853-0044
E-mail sales@arcadiapublishing.com
For customer service and orders:
Toll-Free 1-888-313-2665

Visit us on the Internet at www.arcadiapublishing.com

To Joyce Goodman McRae, who spent years telling me that the history of Latter-day Saints in Tucson needed to be told

CONTENTS

ACKNOWLEDGMENTS

Telling the history of an area with 200 photographs and short captions is always a challenge. Sometimes, these have already been collected in a repository, but this is not the case with the history of Latter-day Saints in southern Arizona. Some photographs have been deposited at the Arizona State Library, Archives and Public Records (ASLAPR), Library of Congress (LOC), Utah State Historical Society (USHS), Brigham Young University (BYU), Tucson Institute of Religion (TIR), and Arizona Historical Society (AHS/Tucson), but many more photographs are still in the homes of private families. Additionally, many descendants of these early pioneers now live in other cities and states. I wish to express my appreciation to all who have supplied images, as credited in parentheses at the end of each caption. Photographs with no attribution belong to the author.

In the 1950s, Tucson Latter-day Saints were raising money for chapel construction. One fundraiser involved the publication of "yearbooks" for the Tucson Second and Third Wards. Kenneth Haymore and Reginald Russell were particularly helpful as photographers. Although Russell was not a member of the LDS Church, he willingly provided his time and expertise as his wife's contribution to the building fund. It is likely that these two men took many of the 1950s photographs.

Candy Hunt created the Lafayette Frost *Firm and Undaunted* painting especially for this book. Other people who have helped include Jim and Linda Bingham, John and Mylie Dahl, John and Sharon Evans, Norman Gardner, Kenneth Rey Haymore, Lucille Kempton, Ramona Lines, Joyce McRae, and John Willis, but most particularly, Duane Bingham and Jeanette Done. Thank you all.

INTRODUCTION

The history of Latter-day Saints in Tucson does not begin in 1899, when Nephi Bingham, his two brothers, Jacob and Daniel, and their father, Erastus Bingham Jr., first began farming along the Rillito, but rather 50 years earlier, when the Mormon Battalion marched through Arizona. And the history of the Church of Jesus Christ of Latter-day Saints does not begin with the march of the Mormon Battalion through Tucson or even with the pioneers being led across the Great Plains by Brigham Young. It begins in New York with Joseph Smith's vision, the publication of the Book of Mormon, and the formation of a truly American church on April 6, 1830. This church, neither Protestant nor Catholic, attracted seekers—people who were looking for a church that reflected their ideas of the primitive church of the New Testament.

Among these early converts were Erastus Bingham of Vermont and his wife, Lucinda, who joined the LDS Church in November 1833. They participated with other members as they moved west searching for religious freedom. By 1846, the Bingham family was at Council Bluffs, Iowa, when volunteers were sought for the Mormon Battalion. Two of their sons, Erastus Jr. and Thomas, enlisted. After military service, they settled in Utah and began grazing their cattle and horses in a canyon southwest of Salt Lake City. They found mineral-bearing rock, but Brigham Young advised against opening a mine. This later became Kennecott Copper's large open-pit Bingham Canyon Mine. The family then resettled in Ogden, and the brothers began families of their own. They operated a shingle mill, herded cows and sheep, milked cows, and made cheese—all the normal pioneer activities.

About 30 years later, Brigham Young began sending Mormons south from Utah to colonize Arizona. The Grand Canyon of the Colorado River was a major physical barrier. Mormon explorer and missionary Jacob Hamblin first crossed the Colorado River in 1858 at the Crossing of the Fathers, located near the Utah-Arizona border. Then, in 1862, he crossed below the Grand Canyon, at Pierce's or Stone's Ferry, traveled past the San Francisco Peaks to the Little Colorado River, and returned to St. George via the Crossing of the Fathers. On this expedition, Hamblin completely circled the Grand Canyon. Frank C. Lockwood, an early Arizona historian, states, "Hamblin broke new trails, crossed the Colorado at every point possible," and between 1871 and 1873, "marked out a hard but practicable route from Utah into the Painted Desert by way of Lee's Ferry, Tuba City, Grand Falls, and up the Little Colorado to Sunset Crossing (near Winslow)." Lockwood concludes, "Jacob Hamblin is one of the pioneer heroes of Arizona. He was a strong, simple, devout man to whom fear was unknown, for he believed himself to be wholly in the hands of God."

These communities—along the Little Colorado River, in the Lehi/Mesa area and the Gila Valley, and at St. David—were the last of Brigham Young's all-Mormon settlements. The only area that had a connection to the Mormon Battalion march was St. David. Mormon settlements were generally farming and ranching communities; church leaders always advised against working in the mines. But by 1900, as geographer D.W. Meinig describes, "The Gathering had lost its

momentum and the concept of a geographically expanding kingdom was no longer feasible. The days of seizing virgin land were long since past and large blocks of land suitable for group colonization were becoming scarce and expensive." This explains why Mormons did not settle in Tucson until the Binghams came in 1899. As one family member remembered, "Times were hard. The children gathered watercress from the ditches, and wood from the foothills for cooking and heating. They also gathered red roots and sold them to a dairy for a penny a bundle."

In September 1909, Nephi Bingham traveled to Mexico. Mormon settlements in Chihuahua and Sonora began about the same time as settlements in Arizona. The impetus for these, however, came from pressure by the government against the Mormon practice of polygamy. Bingham was taking his eldest daughters to attend school at Colonia Juárez, but, with the recent death of his sister, he also wanted to visit his nieces and nephews. Concern over unrest in Mexico helped convince many of Bingham's family members to join him in Tucson.

With the addition of this group of families from Mexico, a formal congregation was organized at Binghampton in 1910 by Joseph E. Robinson, the president of the California Mission. Also, as soon as there was a small group of Mormons in Binghampton, other Mormons felt comfortable coming to Tucson to seek work. Gordon Kimball came from the Gila Valley to work in the bank. Others came from Duncan, Pima, St. David, and Douglas. Another influx of settlers from Mexico came in 1912 after Gen. Jóse Inés Salazar demanded that the citizens of Colonia Dublán give up their arms. Instead of giving arms to the rebels, church leaders encouraged their members to flee Mexico. Many of these refugees ended up in southern Arizona, New Mexico, or El Paso, Texas. Church leaders suggested that these refugees could return to Mexico after it was safe, but many chose to resettle in Arizona, including Tucson.

By 1919, there were two Mormon congregations, one at Binghampton and another in Tucson proper. The Tucson group always included members who came to attend the University of Arizona. Although there were teachers' colleges in Flagstaff and Tempe, students wanting a first-class education came to Tucson. In 1937, the Tucson Institute of Religion was organized to provide religious education and activities for these students, with a building on the north side of campus. Through the years, many distinguished men and women have been part of the university community and the Mormon community.

Latter-day Saints in Tucson were distinctly different from other Arizona congregations. As part of the California Mission, worshippers included descendants of the original Bingham family and descendants of those who came from other Mormon settlements in Arizona and Mexico, but they also included many who simply passed through the area attending the university or working in the community. Today, there are 47 congregations in the Tucson area.

On October 6, 2012, Pres. Thomas S. Monson announced plans for a temple in Tucson. An architectural drawing has not been released, but members in Tucson are anxiously awaiting the construction of the sixth LDS temple in Arizona. Although the story of Latter-day Saints in Tucson is a seemingly unremarkable story, the tenants of The Church of Jesus Christ of Latter-day Saints have influenced the lives of many.

One

THE MORMON BATTALION AND ITS LEGACY

On December 16, 1847, the Mormon Battalion entered the little adobe town of Tucson, and Pvt. Christopher Layton raised the Stars and Stripes above the village. It is thought to be the first US flag to fly over the town and was the beginning of two days of peaceful trade between battalion members and the Hispanic community. The Mexican military had prudently fled to San Xavier del Bac, thereby avoiding military conflict, which neither side wanted.

About 30 years later, Brigham Young called some of these same men to settle in Arizona, and others came of their own volition. Early Mormon settlement of Arizona was difficult, as the people could never produce enough food for completely self-sustaining communities. Many men became freighters, and some even worked in the mines. But they stayed and manned the Mormon settlements. In all, 27 men and two boys who completed the trek to California eventually returned to Arizona. An additional four members of the sick detachments, who never came to Arizona with the battalion, also settled in Arizona.

The first recounting of the story of the Mormon Battalion was published by Daniel Tyler in 1881, but his book failed to put the march into proper context. As historian David L. Bigler writes, Tyler's work "has resulted in the undervaluing or forgetting altogether of some of the command's most notable contributions." This was corrected by Bigler, Norma Ricketts, Will Bagley, and Sherman Fleek, who have each added perspective to the story. The company opened a wagon road from New Mexico to California, but of the 20 wagons that left, only five reached California. They provided enough personnel for Gen. Stephen Kearny to occupy and govern California, and their route through southern Arizona gave support for the later Gadsden Purchase, which included Tucson.

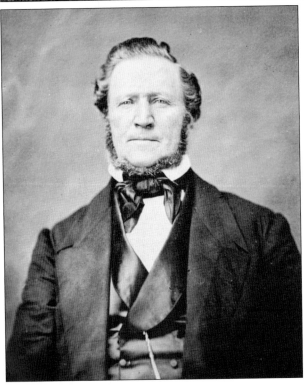

In 1846, approximately 20,000 refugee Mormons were camped at Council Bluffs, Iowa, (above) and scattered across the prairies from Illinois to Iowa. As Brigham Young (left) contemplated their destitute condition and the proposed trek across the Great Plains, he sent Jesse Little to Washington, DC. Help from the government came in the form of a call for 500 men to join the Army and march to California. Enlistments were slow because men were wary of leaving their families. But Young made an impassioned plea, and the quota was soon met. Thus began the famed Mormon Battalion march from Fort Leavenworth to San Diego. The clothing allowance and monthly pay sent back to the church, wives, and children was crucial in financing the initial trek to Utah. (Above, engraving by Frederick Piercy; left, LOC.)

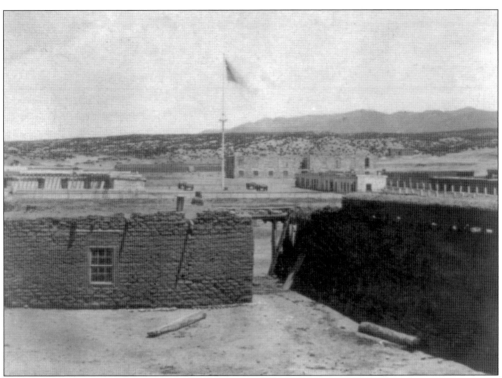

Erastus Bingham Jr. and his brother, Thomas, were members of Company B. When the men reached Fort Marcy at Santa Fe, New Mexico (above), they received a new commander, Lt. Col. Philip St. George Cooke (right). A strict disciplinarian out of West Point, Cooke was appalled by the group he was given to command. They were too old, too young, too undisciplined, and there were too many families. Fortunately, he immediately began to rectify the problems—without him the men likely would have died in the great Southwestern desert. Eventually, both the men and their commander found mutual respect. (Above, LOC; right, *Harper's Weekly*, June 12, 1858.)

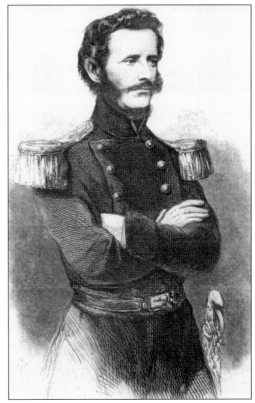

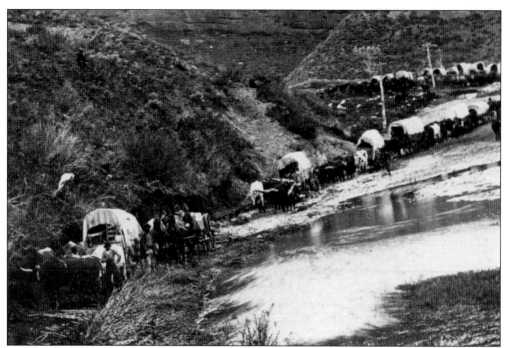

Cooke sent families and the sick to Pueblo, Colorado. Both Thomas Bingham and Erastus Bingham Jr. were part of the group that wintered there with a group of converts from Mississippi. In the spring, they traveled north to the Platte River and entered the Salt Lake Valley just five days after Brigham Young (above, at Emigration Canyon about 1865). They brought two important items with them from Santa Fe: Taos wheat (below) and an understanding of irrigation. At Council Bluffs, Mormons had watered their gardens by carrying buckets of water from the river, but in New Mexico, the men saw the efficiency of irrigation ditches. The Bingham family settled at Ogden. A monument honors Erastus Bingham and his sons, who discovered ore at Bingham Canyon. (Above, National Archives; below, photograph by Edward Curtis, LOC.)

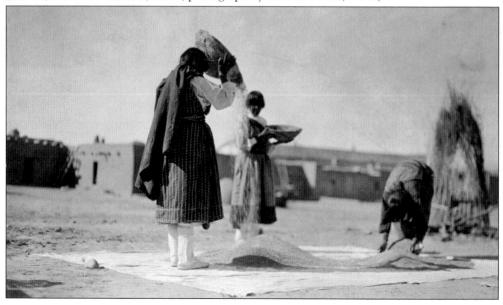

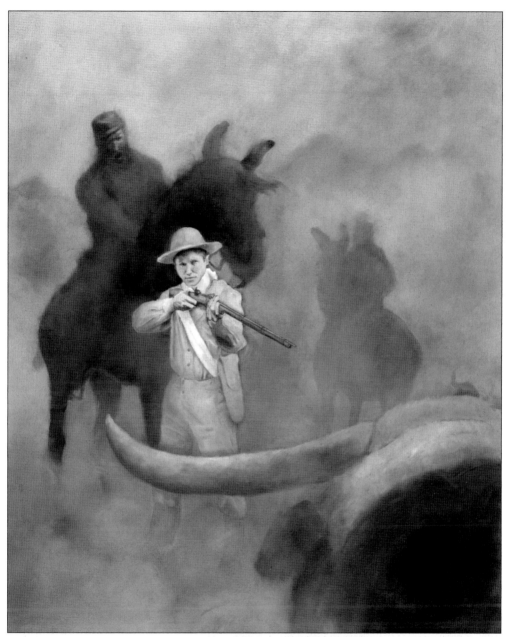

Battalion members blazed trails through miles of rugged terrain, suffering hunger, thirst, and exhaustion. The road they made became known as the Cooke Wagon Road. When they reached the San Pedro River Valley in early December, they fought their only battle—with wild bulls from a ranch abandoned by Ignacio Perez when he fled Apache depredations. Complete chaos ensued, as the bulls ran through camp and attacked randomly. As depicted above, Colonel Cooke was very near Cpl. Lafayette Frost when an immense bull came charging. Cooke wrote that Frost "aimed his musket very deliberately and only fired when the beast was within six paces; it fell headlong, almost at his feet." The encounter left three men wounded and three mules gored to death. John Jefferson Hunt, a third-great-grandson of Capt. Jefferson Hunt, served as the model for Corporal Frost in this painting, *Firm and Undaunted*. (Painting by Candy L. Hunt.)

On December 16, the Mormon Battalion arrived at Tucson, seen above in 1864. The Mexican soldiers had fled, but the townspeople were welcoming. Henry Boyle wrote, "When we arrived here today we were tired, hungry, and thirsty almost beyond endurance. After we had encamped a Short time a few individuals made their appearance from whom we obtained some bread & beans in exchange for shirts & various kinds of clothing." Cooke wrote, "The town . . . is a more populous village than I had supposed, containing about five hundred [people]." He noted a "very large stone church [San Xavier, below]" and a "very large adobe one." The adobe church was an early building connected to the presidio. (Both, LOC.)

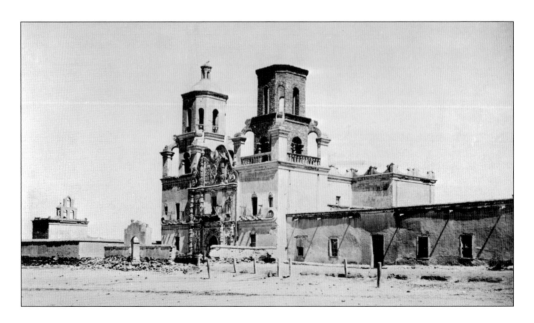

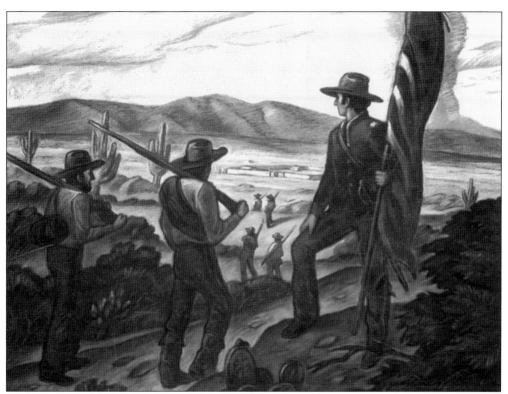

The men spent about three days in Tucson and then followed the Santa Cruz and Gila Rivers to Southern California. Tucson native and artist Howard Post painted *Exchange at the Presidio* (above) in 1996 as a fundraiser when LDS members in Tucson wanted to erect a monument commemorating the sesquicentennial of the entry of the battalion. Earlier, George M. Ottinger had painted his concept of the men finding water along Carrizo Creek (below). Descendants of Mormon Battalion members Jefferson Hunt, Christopher Layton, John C. Naegle, Philemon Merrill, and others have made Tucson their home. (Above, LDS Church History Museum; below, USHS 14678.)

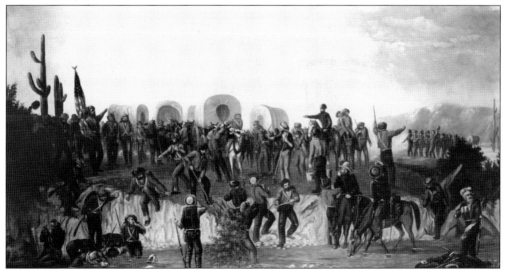

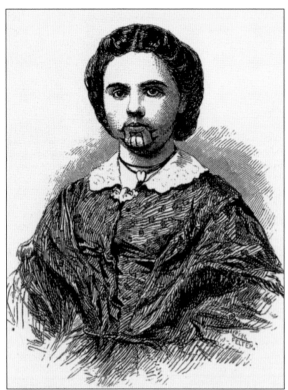

James McClintock mentions unidentified Mormons who were briefly at Tubac in 1851. These were probably part of a splinter group formed either before or after Joseph Smith's death in 1844. The ill-fated Oatman family were also dissenter Mormons. After the slaughter of her family, Olive Oatman, seen here, was sold to Mohaves, who tattooed her chin—see *The Blue Tattoo* by Margot Mifflin. (*Captivity of the Oatman Girls.*)

In 1875, Brigham Young sent the First Expedition into Mexico. Some of these men became part of a second expedition that left Salt Lake on October 18, 1876. At Tubac in early March 1877, they baptized Ramon and Refugio Sardina. These missionaries included James Z. Steward (1), Meliton G. Trejo (2), George Terry (3), Isaac J. Stewart (4), and Helaman Pratt (5). (ASLAPR 03-0117.)

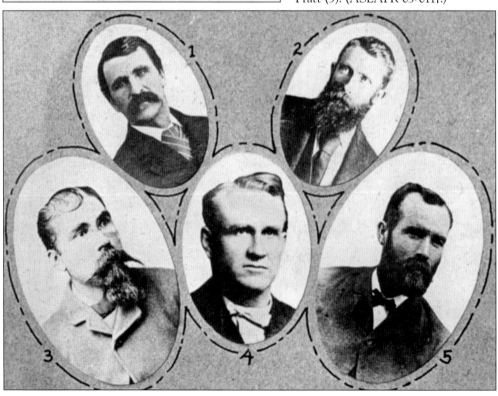

To help Latter-day Saints coming from Utah to Arizona cross the Colorado River (above), ferries were established both above the Grand Canyon, at Lee's Ferry (seen below in 1925), and below the canyon, at Pierce's, Stone's, and Bonelli's Ferries. But immigrants also came by train and directly from other states. Mormon communities were established in Arizona between 1876 and 1885. Beginning in 1885, settlements were also established in Mexico as a result of pressure from the US government over polygamy. These settlements included Colonias Morelos and Oaxaca in Sonora, Colonias Díaz, Dublán, and Juárez on the plains of Chihuahua, and Colonias Pacheco, García, and Chuichupa in the mountains of Chihuahua. All depended upon farming and ranching, but freighting and other endeavors were also pursued. (Above, photograph by David H. Ellis; below, USHS 992.)

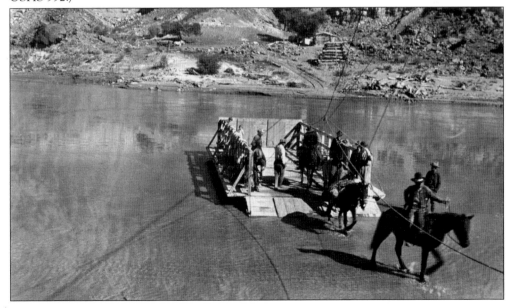

Philemon Merrill marched through Arizona with the Mormon Battalion. In 1877, he came to Lehi-Mesa with the Jones Company via Pierce's Ferry. After one very hot summer, the families of Philemon, Dudley, Thomas, and Adelbert Merrill, George Steele, Joseph McRae (left), and Austin Williams moved to the San Pedro River and founded the town of St. David. (Lorin McRae.)

In 1883, Christopher Layton became president of the St. Joseph Stake, which included St. David and the Gila Valley. Although he had little education, he was an impressive businessman. He rented two entire railroad cars in Salt Lake City and loaded them with horses, mules, furniture, farm implements, seed, alfalfa, oats, wheat, and flour. He settled first at St. David and later in the Gila Valley.

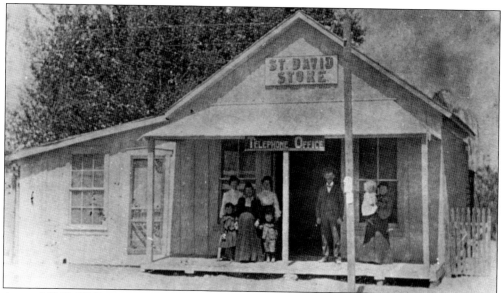

Around 1882, William and Margaret Goodman arrived at St. David to make it their new home. Unfortunately, William died three years later. With nine children ranging in age from two months to nineteen years, Margaret began operating a store out of her living room. Later, the store included the telephone office and the post office. (AHS/Tucson PC91B1-56040.)

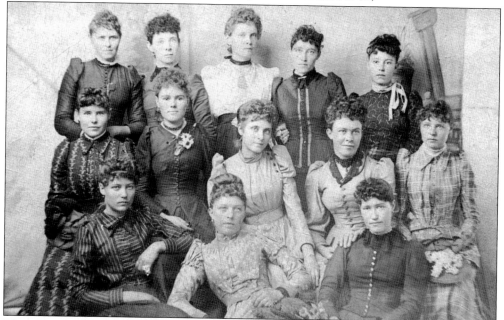

This photograph (taken about 1889) includes girls from St. David who would soon marry and begin families of their own. They are, from left to right, (first row) Louise Trejo, Mamie McGuire (Mary Jane McRae), Roxanna Reed; (second row) Lilly Curtis, Hattie (Stella) Curtis, Sadie Norcross (Merrill), Annie McRae, Florence Curtis; (third row) Iris Curtis, Mamie Fyffe (Eunice "Toony" Summers), Irene McRae (Mary Jane Merrill), Louisa (Mary Jane) Reed, May Clifford (Hattie Curtis). Alternate identifications in parentheses are from a photograph Calvin Bateman gave to the Arizona Historical Society. (Joyce McRae.)

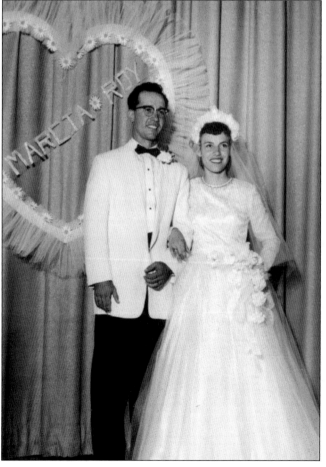

James McClintock interviewed men and women in the Gila Valley for his book *Mormon Settlement in Arizona*. Among these was Samuel Claridge, seen above with his wife, Rebecca, who said, "President Christopher Layton was a great benefactor to this country. He was a man of means and it was through him, very largely, that the country was built up." Their daughter, Kate, was married at 18, a mother at 19, and a widow at 20. In her mid-20s, she served a mission and eventually remarried. Arch and Kate Morrow came to Tucson, and she mothered many in the Tucson Branch. In the 1950s, Samuel Claridge's great-grandson Roy Claridge came to Tucson to attend the university and met Marcia Gardner. They married (left) and made Tucson their permanent home. (Both, Marcia Claridge.)

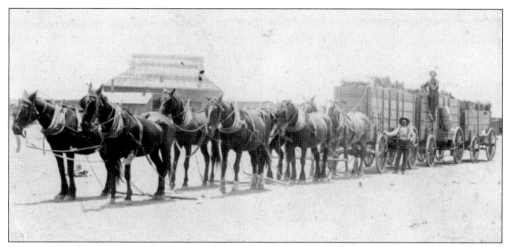

Hyrum Weech told James McClintock that some people moved from the Gila Valley to the San Pedro and others came from the San Pedro to the Gila Valley. One reason they moved to St. David was "because there was a lot of freighting there," particularly hauling goods from the railroad to Tombstone and the mines south of Pierce to Narcozari, Mexico. This freight outfit belonged to William Curtis. (AHS/Tucson 50907.)

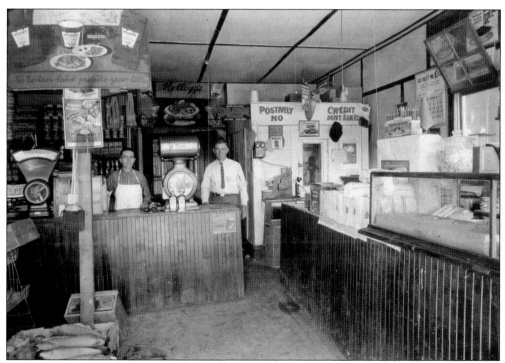

Margaret Goodman operated a store in St. David, and some of her sons and later grandsons also became merchants. Seen here is the interior of the Goodman and Allred store, operated by Francis Goodman in Thatcher. His success came with the motto "Positively No Credit—Don't Ask-It." (Joyce McRae.)

The initial years in Mexico found Mormon colonists nearly destitute. Many lived in dugouts, and food was scarce. However, they worked hard, and soon the towns had every appearance of being imported directly from Utah, with wide streets, brick homes, and neat farms. One of the first buildings constructed was usually a schoolhouse, which also served as a house of worship and a public hall. Above is the Clawson home, in Colonia Dublán. Below, men work on the street of an unidentified Mormon town in northern Mexico. Both photographs were taken shortly before the colonists fled revolutionary unrest in 1912. (Both, LOC.)

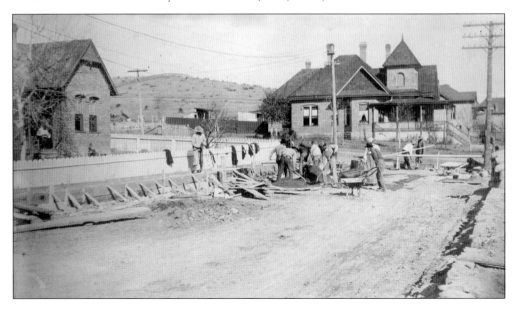

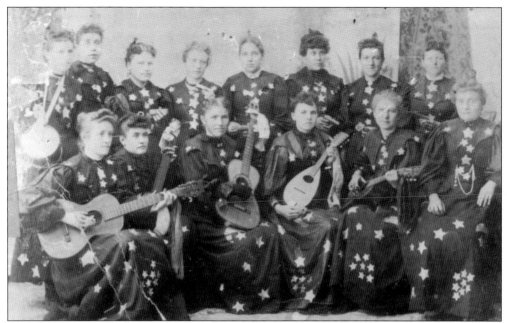

The importance of music in LDS culture is illustrated in the early towns of Colonias Díaz and Juárez. Around 1895, the women of Colonia Díaz began the Stellar Band (above) with one organ, one banjo, one mandolin, one snare drum, three guitars, and seven harmonicas. Seen here are, from left to right, (first row) Phoebe Lemmon, Amanda Tenney, Annie Earl, Lizzie Galbraith, Clara Acord, and Anna Eliza Pierce; (second row) Pearl Whiting, Lulu Johnson, Lizzie Jorgensen, Lucy Pierce, Moneta Johnson, Lois Tenney, Viney Norton, and Domer Adams. The orchestra and the chorus of the Juárez Stake Academy are seen below. The photograph hanging on the wall is of Benito Juárez, an early president of Mexico. Juárez is often compared to Abraham Lincoln, and the colonists named their town in his honor. (Above, Joyce McRae; below, Norman Gardner.)

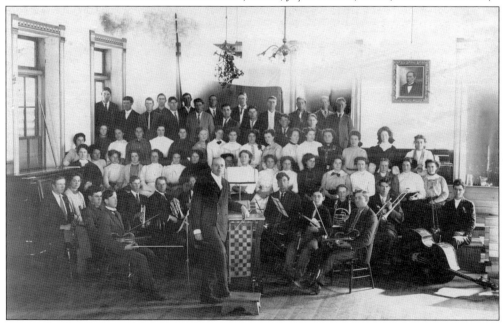

The Haymore family came to Tucson from Douglas. Franklin D. Haymore (left) was an important merchant in Colonias Dublán and Oaxaca. His son David was born in Mexico, lived in Douglas and in El Paso, the headquarters of the Spanish-American Mission, and then moved to Tucson. Seen below around 1953 is the Arizona Temple presidency, from left to right, (first row) Joseph Stradling, Pres. Arwell Pierce, and Henry L. Smith; and mission presidents (second row) Claudious Bowman, Mexican Mission; Loren F. Jones, Spanish-American; David F. Haymore, previous Spanish-American; and Frank V. Anderson, temple recorder. (Left, Jeanette Done; below, Norman Gardner.)

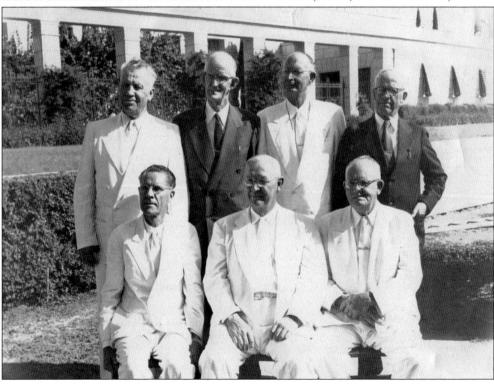

A series of M-Men and Gleaner conferences began in 1935 in Snowflake, with a second conference in Safford in 1936. Then the California Mission sponsored a Tucson conference in 1937. During the convention, a monument was erected at Armory Park remembering the Mormon Battalion; Nadine Post and G.A. McCall planned the program. Forty-seven years later, a flagpole (right) was erected at the church ballpark in Binghampton. Pictured at right are Wayne Goodman (left), Berner Loftfield (center), and Dwayne Morse. Today, Boy Scouts can earn the Mormon Battalion Trail award by learning about the history of the Mormon Battalion and hiking a portion of the trail. The patch below on the left was earned by the Scouts of San Manuel Ward about 1984; the patch on the right was earned by boys from the same ward about 2004. (Right, Wayne Goodman.)

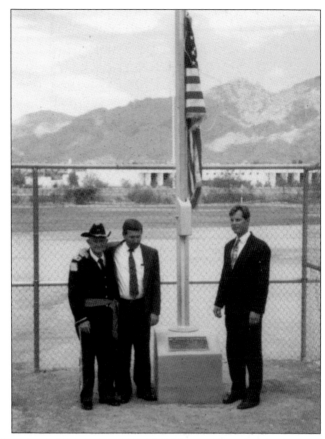

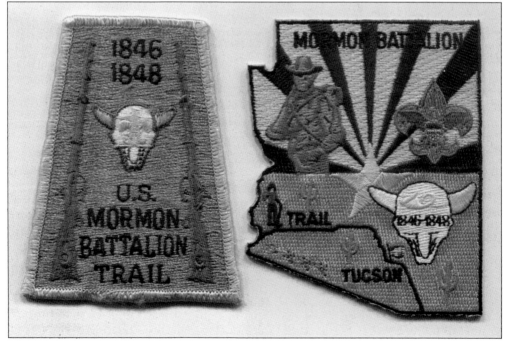

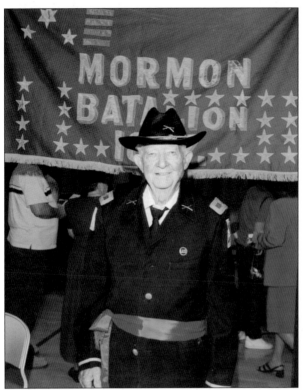

In March 1950, nine busloads of Sons of Utah Pioneers and their wives started south from Salt Lake City for a "reenactment" tour. Stops included Mesa, Yuma, San Diego, and Los Angeles. This led to the establishment of the Mormon Battalion organization in 1954. A second group came from Salt Lake City in 1963 to march in Tucson's rodeo parade. Wayne Goodman (left) was then instrumental in organizing a Tucson Company of the organization and became its captain. This group has marched in the parade every year, and Goodman has participated in every parade except one—when he was serving in the Tampico Mexico Mission. One year after he had heart surgery, he rode a horse, and in later years, he rode in a wagon (below). (Both, Wayne Goodman.)

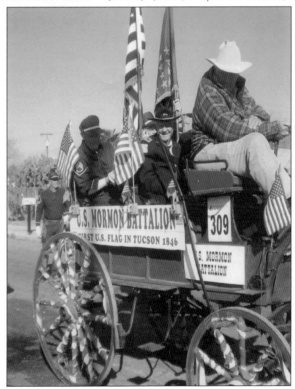

Wayne Goodman is known for giving away copies of the Book of Mormon and for his support of Scouting. In 1984, he was awarded the Silver Beaver Award, and his son Daniel became an Eagle Scout that year. Here, Wayne (right) is shown years later with Daniel. As part of his commitment to Scouting, Wayne raised money for five flags, poles, and stands to be used in LDS chapels. (Wayne Goodman.)

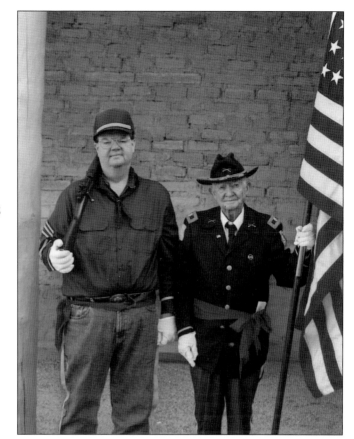

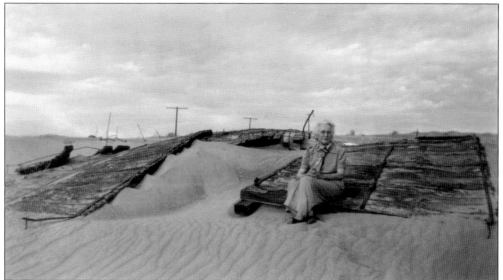

This photograph, although not showing a Mormon Battalion site, nevertheless illustrates the conditions the men found around Yuma. When automobiles came to the Southwest, drivers found sand dunes particularly troublesome and constructed a plank road. Here, Lucy Mortensen sits on the remnants of that road in June 1946. (Joyce McRae.)

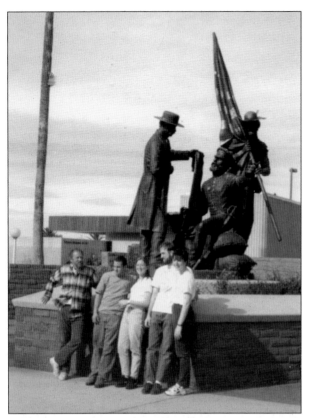

In 1996, the Mormon Battalion visit to Tucson was memorialized with a bronze sculpture by Clyde Ross Morgan of Sedona. Richard Burton, a Tucson architect and stake president, initiated the project. It took eight years to raise the money, produce the sculpture, and put it in place. Three men are shown in this larger-than-life-sized piece. The man sitting is Jefferson Hunt, the captain of Company A. The man standing with the flag is Christopher Layton, a private in Company C and later an important settler in St. David and the Gila Valley. The third man is Teodoro Ramirez, a merchant and leading citizen of Tucson. This grouping illustrates the friendly exchange of goods—primarily excess clothing—for wheat, pomegranates, quinces, and three bushels of salt. At left, the author's family poses for a photograph at the dedication; below, the monument is shown as it looks today.

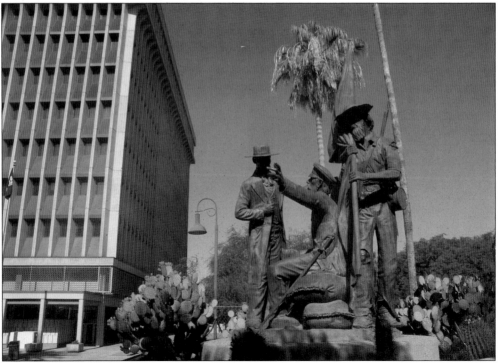

Two

BINGHMAMPTON, ALONG THE RILLITO

Nostalgia best describes the emotion of most who grew up in Binghampton. In this farming community, work and recreation were shared by cousins and neighbors. In 1989, Amanda "Sunda" Johnson Brown called Binghampton a place of "both delights and fears." She was fearful of rattlesnakes, Gila monsters, lizards, tarantulas, scorpions, large red ants, bobcats, and coyotes. But she writes that the "Arizona foothills can provide much of beauty for those who seek it out." She describes stately saguaros as "friendly sentinels," paloverde trees that "in bloom rival forsythia," ocotillos contributing "bright splashes of color against deep blue skies," and the yucca's "great stalks of waxy-white blossoms." She writes, "There were wild sago and mariposa lilies, blue-bells, red-bells, Indian paint brush, wild larkspur, California poppies, and everywhere small white and yellow flowers growing among the desert rocks. All delights!"

In 1899, when the extended Bingham family settled along the Rillito, they realized the need for a year-round water source. Nephi Bingham put in a reservoir and hired local men, including some Native Americans, to dig a gravity ditch. Nephi farmed land that ran along the river for six miles.

As other settlers came, they also began farming. Some grew Bermuda onions, and others had dairies. Probably all of them had chickens and a milk cow. A Mormon woman explained to Will C. Barnes that "the mere fact that she had been a milk cow did not keep us from working her when the necessity arose. It was a long hard road we were traveling, and we needed every available animal to pull those heavy wagons through the sandy washes or over the steep mountains. When she again became 'fresh' she was relieved of her yoke and trudged along with the rest of the loose cattle being milked twice a day. We had lots of babies and very young children for whom the milk was a vital necessity. Those dry milk cows, however, could pull a load as well as any ox that ever wore a yoke."

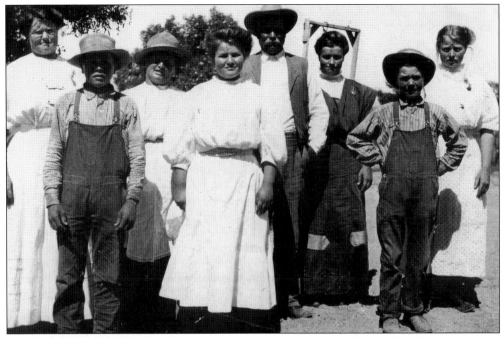

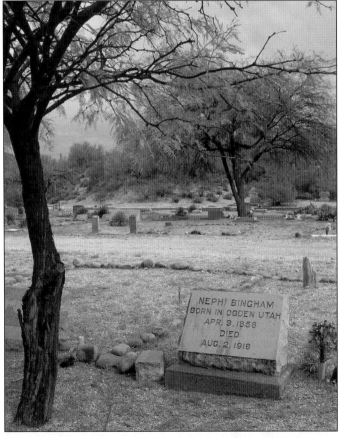

Nephi Bingham was born in Utah, and by the time he was in his mid-20s, was hauling freight in New Mexico for the government. While in Silver City, he met a young Englishwoman, Elizabeth Dalkin, and they married in 1887. They lived in Moab and Richfield, Utah, and Mancos, Colorado; their fourth daughter was born in Casa Grande, Arizona. The photograph above shows the Bingham family. They are, from left to right, Rebecca, Floyd, Elizabeth, Edna, Nephi, Mae, Glen, and Clara. Another son, Delbert, was born when Glen was 12 years old. Edna said, "We were so happy and loved him so much as we couldn't remember when we ever had a little baby in our home." (Above, Duane Bingham; left, photograph by Christopher Lucic.)

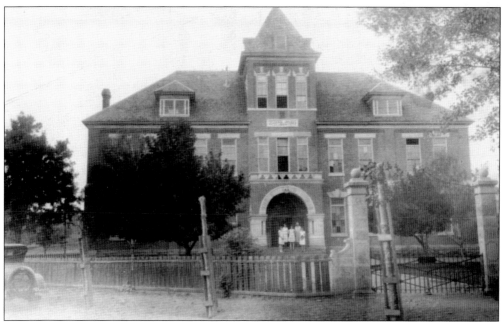

In September 1909, Nephi Bingham took his two eldest daughters to Colonia Juárez to attend school (above). He also visited with his nephew, Heber Farr, and suggested that, with revolutionary unrest in Mexico, the extended Farr family should move to Tucson. Farr and Charles Hurst returned to look over the Tucson possibilities and decided to make the move. "Nephi Bingham and his younger brother, Jacob," said Edna Bingham Sabin, "made preparations for the colonists' arrival at the Rillito, where turkeys, ducks, chickens, eggs, dried corn, beans, dill pickles, sauerkraut, pumpkins, bottled fruit, and five gallons of mincemeat awaited them. They butchered and cured a pig, and Nephi killed a beef." Below, Jacob Bingham is seen later with his children. His wife died of influenza in 1919. (Both, Duane Bingham.)

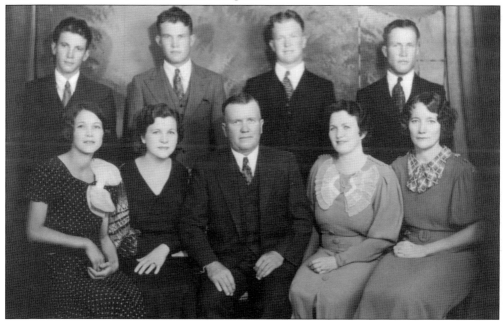

"On December 15, 1909, in the afternoon," Edna Sabin wrote, "eight covered wagons came rolling out of the catclaw and chaparral bush down the lane to our home. It was a wonderful meeting to see them all for the first time. They parked their wagons between our home and Uncle Jacob's home. Some of them were very sick when they arrived. The sick and the old people slept in the two homes and the others slept in the covered wagons." The men began building tent houses. Above left are William Harrison Young and children—from left to right, Mae, Bill, James Brown (neighbor), and Kent. Above right, Effie Mae Butler Young is with Kent and baby Ronal standing in front of their tent house. A more substantial board home belonging to Louisa Done is below. (All, Jeanette Done.)

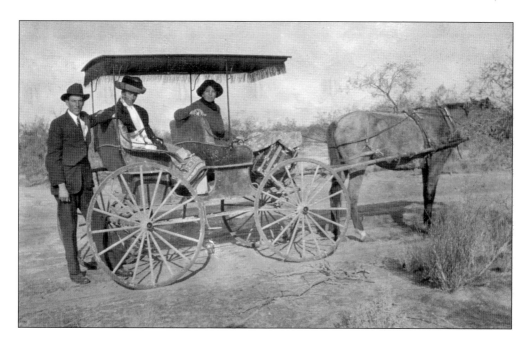

Edna Sabin told of attending dances at Binghampton one Saturday night and then at Jaynes Station the next. "My father furnished transportation," she said. "He had a large wagon and a hay rack on it and two spans of mules. The boys would fill the hay rack full of hay and stretch canvas over it and then some quilts. My father gave the drivers a little bell and said, 'Don't whip the mules, just ring this bell and they will go fast enough.'" The Done family's first transportation is seen above. Pictured, from left to right, are Eli Abegg, Louisa Done, and Martha Jesperson. They noted that the horse always traveled faster when coming home. A second common mode of transportation was bicycles. Below, Richard Done (right) is seen with an unidentified missionary, April 15, 1930. (Both, Jeanette Done.)

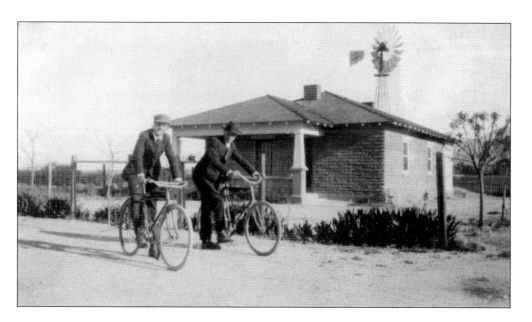

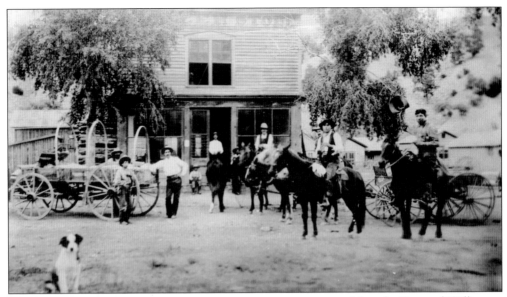

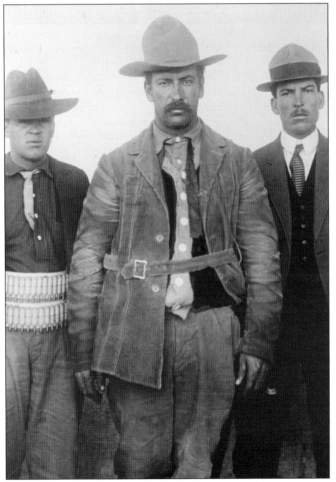

After the Farr and Williams families left Mexico in 1909, Mormon colonists in Chihuahua and Sonora tried to follow advice from the LDS Church and the American government leaders and remain neutral. This period saw armies following Pasqual Orozoco Jr. and Emiliano Zapata protesting the government of Francisco Madero. The armies swept through both non-Mormon and Mormon towns (like the one above), confiscating guns, ammunition, food, and horses. Mormons imported guns to defend themselves, but this only emboldened the revolutionaries. In July 1912, Gen. Jóse Inés Salazar (left, center) demanded weapons from the residents of Colonia Dublán. Stake President Junius Romney felt there was no choice left but to flee. (Both, LOC.)

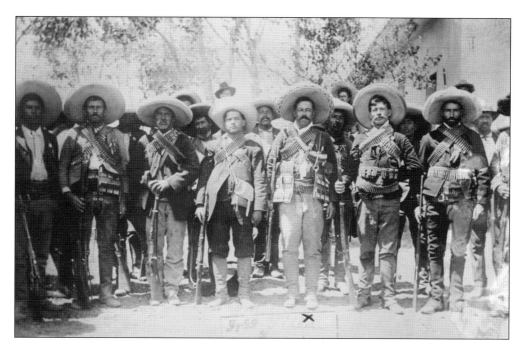

The causes of the Mexican Revolution are complex, but the danger was real. Trains were burned and foreigners were killed, with Chinese merchants suffering the worst. Today, Francisco "Pancho" Villa (above, "x") is generally charged with the depredations. When the Mormons fled in 1912, residents from the plains of Chihuahua crowded onto the train and departed to El Paso, Texas. Residents of the Chihuahuan mountain villages fled in wagons and crossed the border at Columbus, New Mexico. Mormons in Sonora retreated to Douglas, Arizona. Not knowing if they would be returning to Mexico, the refugees lived in tents at Hatchita, New Mexico, and in a lumberyard in El Paso (below). (Both, LOC.)

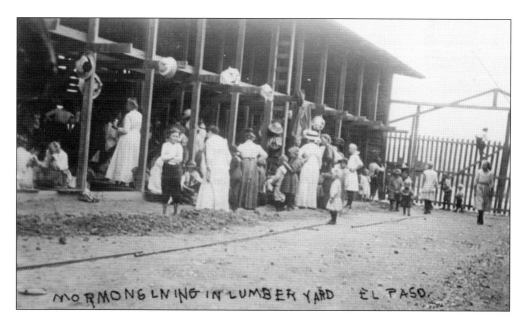

One of the problems the refugees from Mexico encountered after returning to the United States concerned the practice of polygamy. The responses varied, with some families living in separate towns and others quietly continuing to live together. Law enforcement generally left polygamists alone, believing the practice was dying out. Louisa Done originally married Arnold Abegg, and after his death married Abraham Done as his second wife. When the family returned from Colonia Dublán, Abraham settled in Mesa and in Utah, and Louisa lived in Tucson. Above, from left to right, are Otto, Bill, and Richard Done, Eli and Moroni Abegg, and Oscar Jesperson, a son-in-law. Eli and Moroni Abegg built their mother a home on Dodge Boulevard about 1914, and they built a nicer one made from homemade adobes (below) on Fort Lowell Road around 1920. Louisa worked hard to support her nine children. (Both, Jeanette Done.)

Louis P. Cardon had three wives. His first wife, Ellen, and his older children moved to the Gila Valley so the children could attend school at the Gila Stake Academy, but Louis lived with his second and third wives in Tucson. For the 1920 census, Edith Cardon's husband is listed as L. Paul Cardon, and Irena Cardon's husband is listed as Louis Paul Cardon. Both women had children born in Tucson, but they did not record the births with the state. By 1940, only Irena was still living in Tucson. She is seen at right with her daughters Amy (left) and Edna. Another family that continued to practice polygamy in Tucson was Frederick Williams II and his two wives Amanda and Nancy. He is seen below with Amanda in 1914 at the Bean Ranch. (Right, photograph by Max Hunt; below, Duane Bingham.)

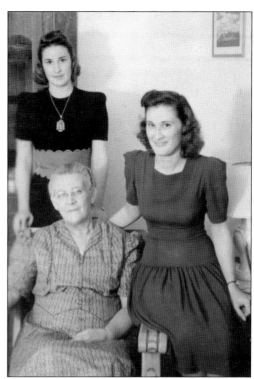

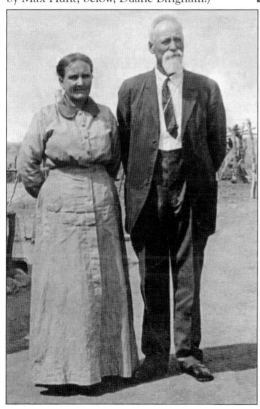

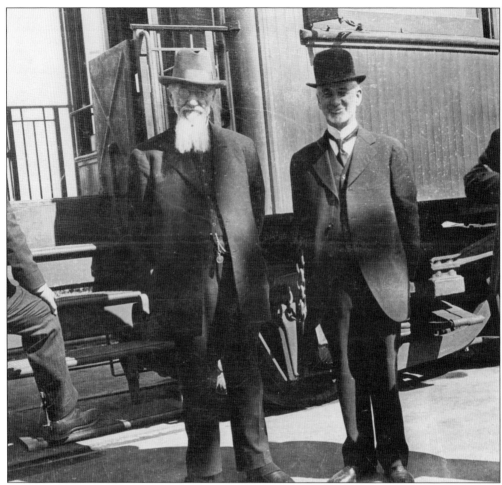

In late 1913, Pres. Joseph F. Smith (left) traveled to Arizona. A private railcar, which could be sidetracked for several days, provided a place to entertain visitors and sleeping accommodations for his party, including Presiding Bishop Charles W. Nibley (right [photograph not in Tucson]). They dedicated a high school in Snowflake and two chapels in Mesa, and held conferences in Mesa and Thatcher. The last stop was Tucson, where city dignitaries Mose Drachman, Albert and Harold Steinfeld, and Col. Epes Randolph provided lunch at the Old Pueblo and transportation to San Xavier. President Smith met with the Saints in Binghampton and said he counseled them to "settle right where they are in Arizona, to buy their land and go to work, and if they cannot buy land to go to work anyhow. We have impressed it upon them that they will be much better off in doing this than in drifting about from one place to another, then if in a few years things settle down, they can go back, if they wish, to Mexico." (USHS 11496.)

The most important task in establishing a farming community in the Sonoran Desert is finding a water source. For the early settlers, this meant diverting water coming down from Mount Lemmon or pumping water using a windmill. Above, a windmill behind the Done home pumps water into a large cement box, which was not only used for water storage but also as an early swimming pool. At right is the pump, which replaced the windmill. Binghampton had ditches running parallel to the street to provide irrigation for gardens and orchards. Until 1930, water barrels were filled from these ditches—early in the morning before the cows used them. Eventually, Eli Abegg ran pipes from his well to nearby homes. (Above, Jeanette Done; right, Duane Bingham.)

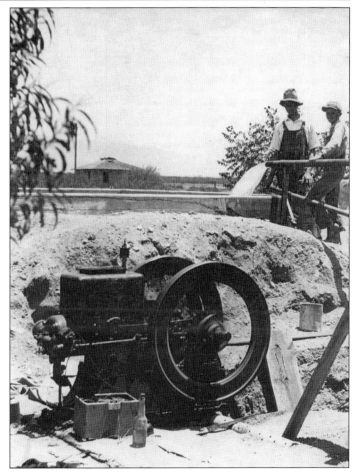

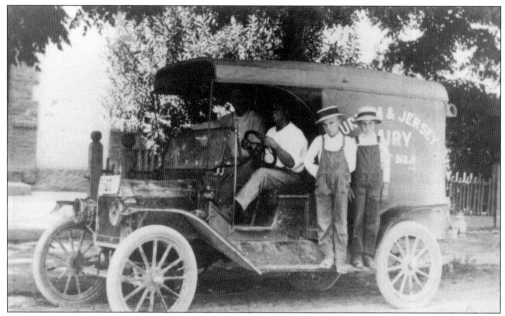

Will C. Barnes reports that an old-time cowboy said, "First-class cows and horses must have been a part of the Mormon religion, judging by the way the believers in that faith managed to always have them, no matter where they located." In Arizona, Mormon Devons soon replaced Texas longhorns, and by 1912, Nephi Bingham was raising prize-winning Ayrshire dairy cattle near Tucson. Above, Harvey Webb delivers milk for the Guernsey and Jersey Dairy in Tucson. Below, Florence (left) and Gertrude Naegle, dressed in Sunday clothes, pose with two newborn calves in 1914 in Miramonte, a town near St. David that no longer exists. (Above, Jean Webb; below, AHS/Tucson PC91B1-56063.)

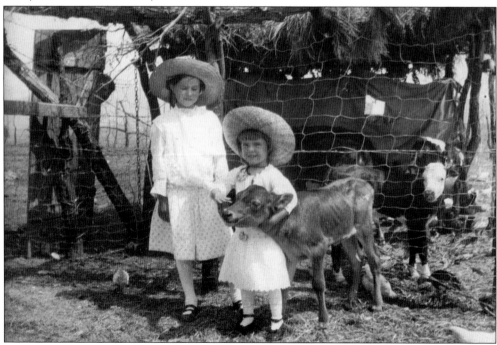

In the photographs above, Eva Naegle and Richard Done show off produce from Binghampton. Naegle, in her swimming suit, stands in front of baled hay, while Done shows off a huge watermelon. Edna Sabin said that Nephi Bingham "planted wheat, barley, oats and alfalfa. He had a big garden of all kinds of vegetables—corn, potatoes, tomatoes, beans, pumpkins, cabbages, onions, peas. We had fields of strawberries, blackberries, logan and raspberries, all kinds of fruit trees." The photograph below shows a field, likely growing wheat or barley. (Above, both, Jeanette Done; below, Duane Bingham.)

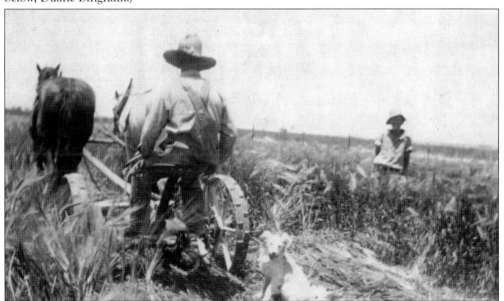

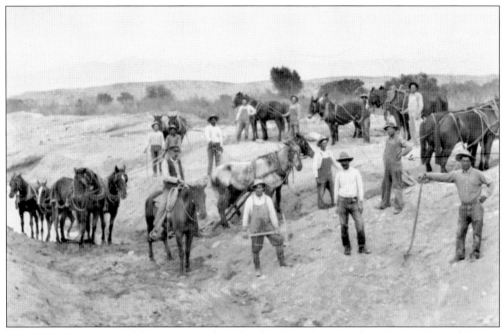

Often Mormon men could not support their families from farming alone, but with good horses, they were able to supplement their income with roadwork. Above, the road crew of Jacob Bingham (indicated with an arrow) is hard at work, likely on Redington Pass. Men working with horses and mules used either slip or fresno scrapers. Below, Frank Webb is working for Pima County putting in the Mount Lemmon road. This photograph was taken shortly after his wife, Edith, died in a car accident, on July 29, 1935, as she returned home from a reunion in Utah. After her death, work became a solace to him. A total of seven members from Binghampton were killed, including Pearl Bingham Bischoff, the daughter of Jacob Bingham, and her husband and two daughters. (Above, Duane Bingham; below, Jean Webb.)

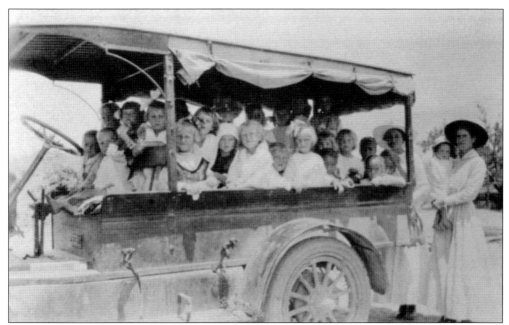

Latter-day Saints believe children are a blessing from heaven and take seriously the responsibility of religious education. Above, Heber Farr's truck is loaded with children, presumably on their way to Sunday School, likely in the 1920s. Below is a 24th of July Primary children's parade in the 1950s. Little red wagons were decorated as floats, including from right to left, "The Children's Friend," after a magazine for children; four little nurses; a birthday cake float with "We will soon be 8 yrs old" written on it, meaning they are nearly ready for baptism; Uncle Sam; and a wagon with "And They Shall Teach Their Children to Pray" written on it. Directly behind the birthday cake are the three sons of the bishopric, dressed as their fathers with a sign reading, "The 1st Ward Bishopric." (Both, Gerald Jones.)

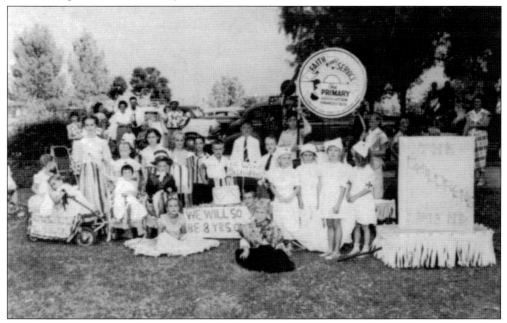

Shortly before his death, Alexander J. Davidson (left) said, "I have always tried to leave every place I've been a little better than I found it." Originally from Cadiz, Ohio, Davidson came out west via Cape Horn and by 1880 was in Tucson. He became a successful businessman and leased 60 acres of land north of the Rillito River to Nephi Bingham in 1899–1900. Davidson was always interested in community affairs, particularly education. He had graduated from college in Cadiz, and after the Binghams settled in Tucson, he donated land for a school. In the early years, Davidson served on the school board. Below is the second school, which had a single large room, divided into four classrooms with bright red curtains, and a stage, where another class met. (Left, AHS/Tucson 105; below, John Evans.)

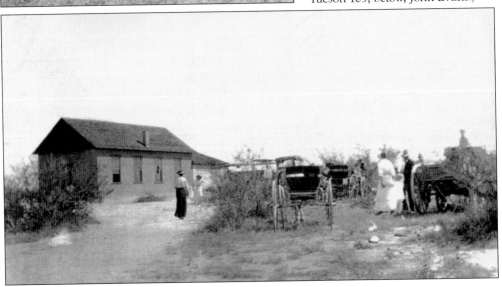

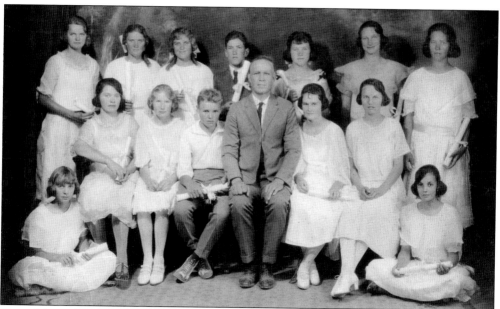

One of the early schoolteachers was George Clawson from the Gila Valley, seen above with the graduating class of 1923. The photograph includes, from left to right, (first row) Veneta James, Mildred Cardon, Thora Young, Grant Johnson, Clawson, Mae Martin, Sarah Clawson, and Veda Nelson; (second row) Dora Nelson, twins Marie and Maurine Hardy, Edwin Bingham, Thelma Bingham, Milda Farr, and Loretta Rowley. Clawson played football for the University of Arizona in 1914 and was known by his teammates as the Big Mormon. Below is a class of Davidson School students about 1924. Junius Evans is seated second from the left in the first row. The Davidson School was used on weekends for socials, dancing, and church. The stage was used for operettas and plays. (Above, Jeanette Done; below, John Evans.)

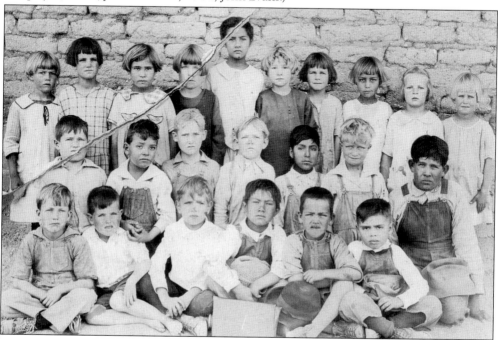

In 1925, Daniel Dudley Jones (pictured) taught seventh and eighth grades at Davidson School, and his son, LeBaron "Lee," taught fifth and sixth grades. There were 155 students, with 13 in the graduating class. Davidson and Fort Lowell Schools were two miles apart, and the children would frequently walk the distance to compete in games and spelling bees. Daniel Jones was later the principal of Davidson School. (Gerald Jones.)

Although most residents of Binghampton were Mormons, Parvin and Harriet Ramsower came from Texas in 1935 and leased the grocery and gas station at Fort Lowell Road and Maple Street. Harriet always had soup on the stove for the schoolchildren, which was much appreciated during the Great Depression years. Their son Paul, seen here, took over the grocery business in 1951. (Duane Bingham.)

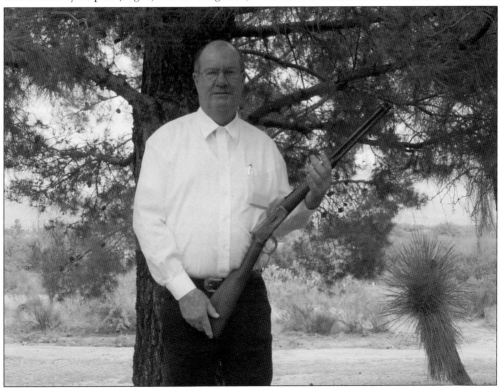

Edna Sabin said that Nephi Bingham built three big reservoirs where wild ducks came in "by the hundreds." Nephi's sons, Glen and Floyd, "would go duck hunting every morning" and sold ducks to the market. They usually took their dogs, Shep and Tob, to act as retrievers. One morning, however, Shep jumped up at the wrong time and Glen shot him, ruining duck hunting for Glen. At right, Elmer Bingham is ready to go hunting. Below is Jim Bingham, a great-grandson of Nephi, with a gun identical to one owned by Nephi. (Right, Duane Bingham.)

On February 14, 2012, Christopher Lucic celebrated Arizona's 100th birthday by stopping to photograph the historic Binghampton Cemetery (above). This cemetery began with the burial of John Harris, a friend of the Bingham family, in 1899, but the land was not deeded, and the graves very nearly had to be moved because of the Homestead Act during the Great Depression. The community sent Orrin Williams to Phoenix, and eventually he was able to secure title to the land. However, the cemetery continued to languish until Eli Abegg assumed care of it in 1964. Abegg built the front wall and began documenting unmarked graves. When Millard Bingham (below left, with Abegg) became the caretaker in 1981, the cemetery was neat but not yet beautiful. (Above, photograph by Christopher Lucic; below, Duane Bingham.)

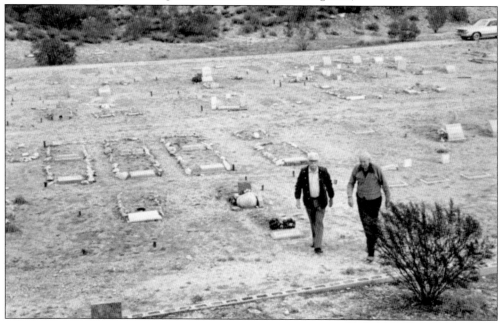

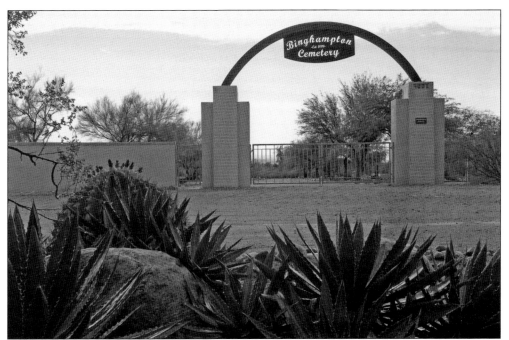

By 1990, Duane Bingham began helping his father with the cemetery. Duane installed 2,500 feet of water lines and began planting shrubbery—paloverde and mesquite trees and other desert plants. With the extra water, the plants began to thrive and bloom, and water drips were provided for rabbits and quail. Finally, in 2010, an iron gateway (above) was installed through an Eagle Scout project directed by Tanner Morse (below), a descendant of the Hardy family, early Binghampton settlers. The fabricating expertise of Morse's father, Dwayne, produced a beautiful entrance to this historical desert cemetery, which has been used by the Mormon community for over 100 years. (Above, photograph by Christopher Lucic; below, Dwayne Morse.)

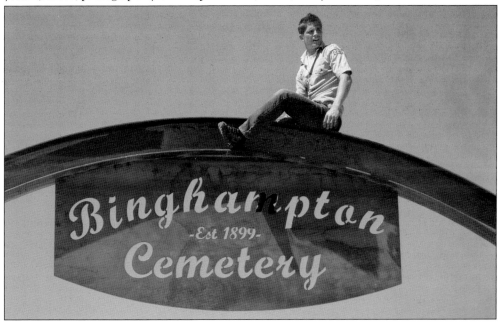

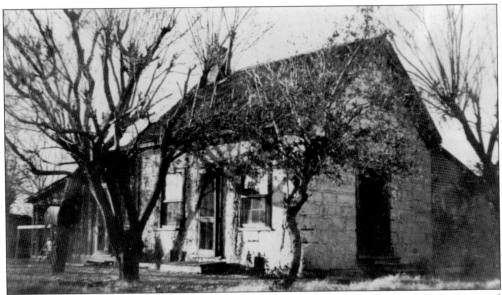

This house, at Dodge and River Road, was built in 1901 and became the home of Heber Farr and his two wives, Amanda Elizabeth "Lizzie" and Hilda. The left side of the house belonged to Hilda and the right side to Lizzie. The wooden lean-to on the left was Hilda's kitchen, and the shed at the back was Amanda's. Cooking "outside" in the heat of summer was very practical. In 2003, this area became part of the Binghampton Rural Historic Landscape, which is listed in the National Register of Historic Places. The Brandi Fenton Memorial Park (below) was created in 2005 to remember the life of a young girl who loved butterflies and flowers. Large outdoor billboards help visitors understand the history of Binghampton, and historic buildings have been combined with a butterfly garden to create a multiuse area. (Above, Gerald Jones.)

Three

THE CALIFORNIA MISSION

One of the characteristics of the Church of Jesus Christ of Latter-day Saints is a lay ministry. However, with a priesthood trained on the job rather than in a university, surprises are the norm. Leslie Brewer is remembered as a strict bishop and stake president, but he also told the following story. Around 1945, he was a counselor in the district Sunday School, and they went to St. David for a visit. The superintendent, Brewer said, "resolved to eliminate cigarettes from that congregation once and for all. He took along a large white rabbit and a hypodermic needle with enough nicotine in it to wipe out a good size army. After explaining all the evil things nicotine does to one, he asked the assembly to see what it would do to the rabbit. He injected a lethal dose. The rabbit perked up and . . . [we] kept waiting for the rabbit to drop. The rabbit felt fine." Finally, the superintendent gave up, told the children to go to class, and come back to see the effects of nicotine. "As far as I know," Brewer concluded, "the rabbit lived out a long, natural life."

As part of this lay leadership, men and women give large amounts of their time to make the congregations function, all the while working at regular jobs to support their families. There is no room to list everyone who has helped make the churches in Tucson flourish, but men and women have directed choirs, played the organ, taken Boy Scouts on hikes, inspired girls atop Mount Lemmon, donated time and money to building chapels, worked at the church farm, gone on missions, prepared food for funerals, taught Primary classes, counseled troubled teens, paid tithing, compiled family histories, organized blood drives, served at the temple, repackaged food for the community food bank, donated used items to Deseret Industries, planned musical productions, chaperoned dances, taught seminary, conducted countless meetings, and given thousands of sermons. Such tireless service should never be forgotten.

On May 22, 1910, about 45 people gathered under shade trees near the home of Heber Farr. With Bingham family members and the Farr, Williams, Young, and Webb families, Joseph E. Robinson (left), president of the California Mission, traveled to Tucson and organized the Binghampton Branch. Heber Farr, seen below with his two wives, Lizzie Williams (left) and Hilda Bluth, became the first branch president. Additional members came from Mexico two years later. Edna Bingham Sabin remembers, "When the Mormons living out[side] of Tucson heard that there was a branch of the Church near Tucson, they came from Safford, Thatcher, Duncan, Pima, St. David, Douglas, and Benson . . . The Saints living in Tucson came to Binghampton to attend Church services, dances, entertainments, and home talent plays." (Below, Gerald Jones.)

Gertrude and Parley "Buster" Naegle, the youngest children of Daniel and Altia Naegle, are dressed and ready for church about 1918. When the family fled Mexico, they first homesteaded at Miramonte and then tried farming at Flowing Wells. Because the only congregation was in Binghampton, the family motored there each Sunday from Flowing Wells. (AHS/Tucson PC91B1-56061.)

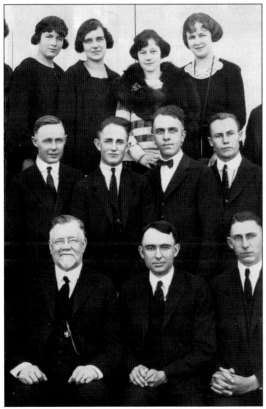

In March 1921, Joseph W. McMurrin, the president of the California Mission, traveled to Tucson and organized the Tucson Branch with missionary David W. Hulet as president and Alando B. Ballantyne and Oscar Atkinson as counselors. The branch met first in the Odd Fellows Hall. McMurrin is seen here (first row, far left) with missionaries in San Bernardino, California, including Alexander Schreiner (second row, second from right), who later became the Mormon Tabernacle Choir organist.

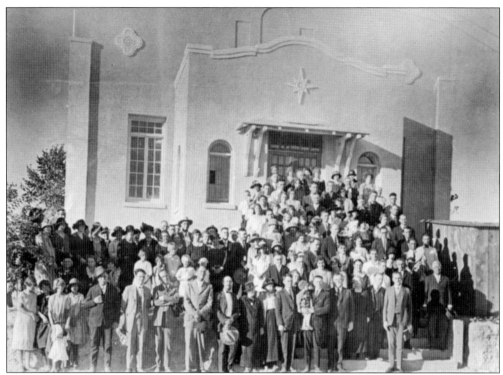

The Tucson Branch began construction on the first LDS church in Tucson in 1921. This building, at Fremont and Sixth Streets, was completed in 1925. It is seen above in 1934. Besides the chapel, it had three classrooms, a full-sized basement with a cultural hall, a stage, and a baptismal font, and an upstairs apartment sometimes used by missionaries. When the congregation outgrew the building, the house to the east (below, right) was also purchased and used for classrooms. With a new church built in 1955, this building became the "old" Loft Theater before eventually being torn down in 1997. (Above, AHS/Tucson PC91B1-56046; below, Marcia Claridge.)

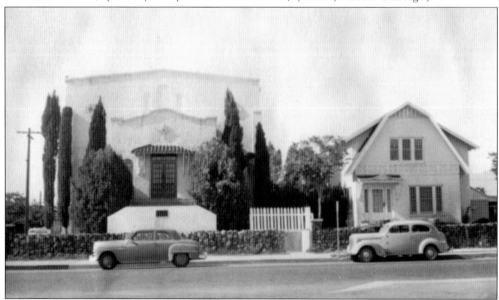

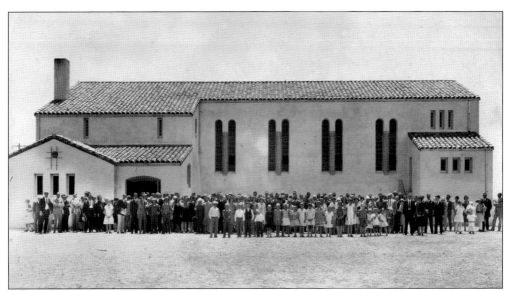

As was common for many pioneer Mormons, early church services in Binghampton were held at the Davidson School. Eventually, a separation of church and civic activities was needed, and plans were made for a church at 3700 East Fort Lowell Road. Oscar Jesperson traveled to California for inspiration and chose a Spanish-Romanesque style for the building. Construction began in 1927, with church members providing much of the labor, including the excavation of the basement with teams and scrapers. Above, the building was dedicated on February 26, 1936, when all construction costs had been paid, although the structure had already been in use for several years. Below is an early group of Singing Mothers in front of the church. (Above, Duane Bingham; below, Gerald Jones.)

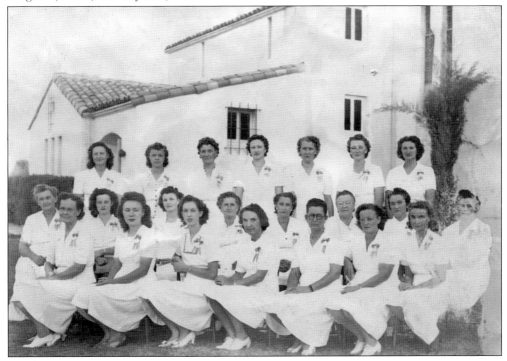

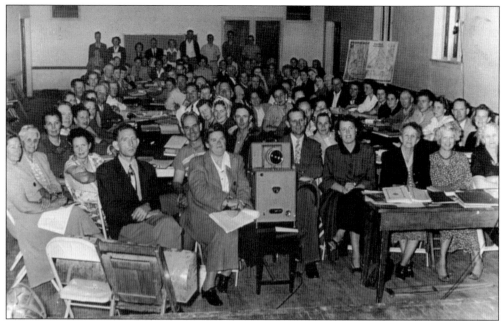

With a temple in Mesa, James W. LeSueur turned his attention to genealogical research throughout the Arizona Temple district. Around 1930, the class pictured above was taught at the Binghampton church, complete with a projector. LeSueur said, "It is to be hoped that the Junior Genealogical Society classes will prepare and enthuse so many young people that ere long there will be genealogists to carry on in nearly every family." Below, one of these classes had a "heraldry" sign, which reads, "The Hearts of the Children Shall Turn to their Fathers" (Malachi 4:6), and includes the Angel Moroni, a heart, a star, a temple, hands, and the world. The adults in the photograph are, from left to right, (second row) Elizabeth Johnson, Cordelia Butler, Isuara Abegg, Louisa Done, and Edith Webb; (third row) Nancy Williams, Bill Jesperson, Frank Webb, and Jake Bingham. (Above, Duane Bingham, below, Jean Webb.)

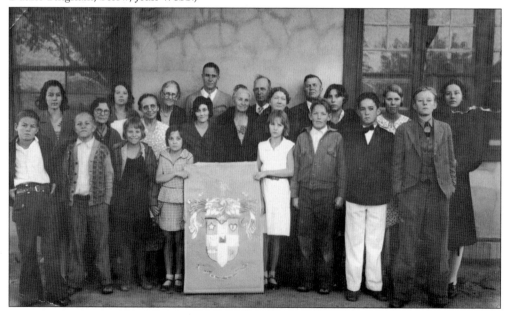

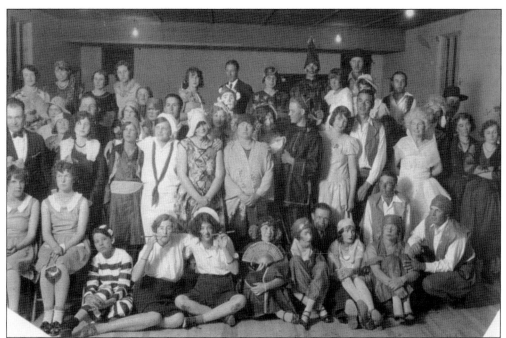

Dancing has been an important part of Mormon culture from the time when pioneers crossed the plains to the present, so it is not surprising to see dances held at an LDS church. The costumed dance above was in the basement of the Binghampton church around 1930. However, there were not many congregations that operated swimming pools. The pool at right, next to the Binghampton church, originally had an 18-foot diving tower for its 8-foot depth. The dangers of this combination eventually became evident—fortunately without a terrible accident—and the top of the tower was removed. This pool and a pool on Wetmore Road were the only public pools north of Tucson for many years. (Both, Duane Bingham.)

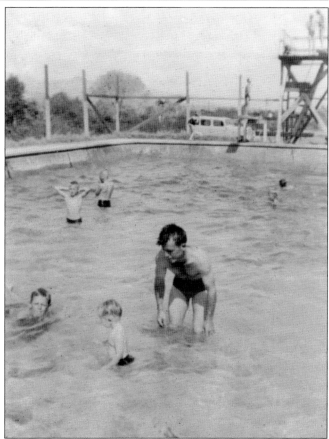

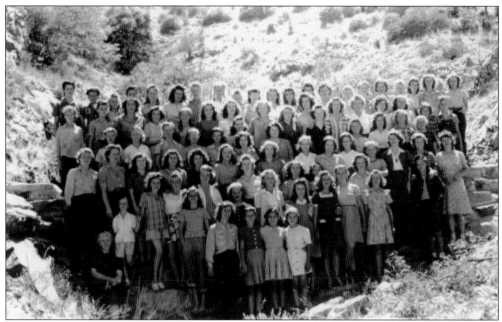

Binghampton boys were organized into Scout troops in 1921, and LDS girls from Tucson have also participated in a week of camping each summer. The group of Bee Hive girls above from the Southern Arizona Stake poses for a photograph on a campout to Bisbee in 1942. In later years, the girls traveled to Mount Graham for their week of camping (below in 1951). George Standage, a member of the bishopric, provided his lumber truck to transport the girls, their camping gear, and food, including watermelons, which rolled around in the truck. At 10,000 feet in elevation, this camp was a welcome relief from Tucson's summer heat, although there were occasionally bears. (Both, Duane Bingham.)

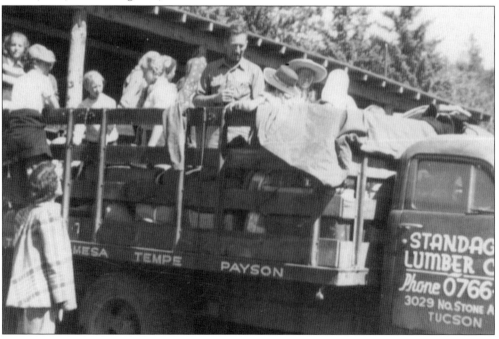

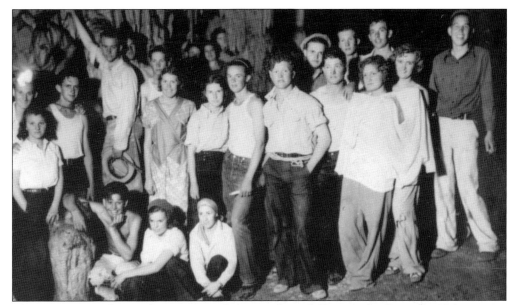

This 1932 outing for Binghampton youth was to Crystal Cave in the Santa Rita Mountains. The group includes, from left to right, (seated) unidentified, Pearl Nelson, and Doris Bender; (standing) Bill Young, Edna Sorrells, Marvin Price, Jim Jesperson, Alton Bingham, Viola Stock, Goldy ?, Carl Nelson, Elmer Bingham, Grant Johnson, Delbert Bingham, Ivan Young, Mercelle Farr, Dan Jones, Alice Bingham, and Arlo Richardson. (Duane Bingham.)

The first LDS Sunday School in Utah was established by Richard Ballantyne in 1849, when he saw a need to teach children about the gospel. A little more than 100 years later, this Sunday School met in the Tucson chapel on Sixth Street. Uriah Wood was the superintendent and children aged four to ten formed the Junior Sunday School. Note the sloped, theater-type seating in the chapel. (Kenneth Rey Haymore.)

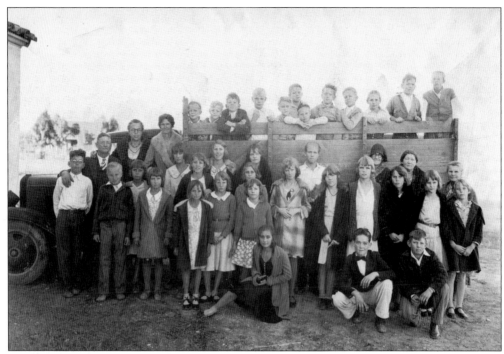

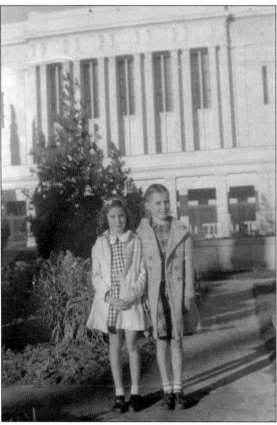

In 1921, when an Arizona temple was being considered, Mesa was not the automatic choice for its location. People in Thatcher, St. Johns, and Snowflake each proposed that the temple be in their towns. Mesa's central location, however, proved to be a great blessing, and five days of dedicatory services began on October 24, 1927. Above, Tucson children get ready to make the trip to Mesa in 1932. Their mode of transportation, in the back of a cattle truck, would be unacceptable today—hopefully the trip was not in the heat of the summer. At left, Eleanor Pyper (left) and Lucille Brewer pose in front of the temple in the early 1940s. LeRoy B. Pyper was the president of the Tucson Branch when it became a ward in 1941. (Above, Duane Bingham; left, Lucille Kempton.)

In 1941, the Southern Arizona Stake was formed, with its headquarters at St. David. Both the Binghampton and Tucson Branches became wards in this stake. Then in 1950, Binghampton Ward became Tucson First Ward, and the Tucson Ward was divided into Tucson Second and Third Wards. Construction was begun on two new buildings. At right, the Southern Arizona Stake presidency, including, from left to right, Leslie Brewer, president Jared Trejo, and Bruce Gibson, turns the first shovel of soil for the Norton building. Below, Joyce McRae holds a 22-carat-gold-edged souvenir plate that sold for $5 as a fundraiser. (Right, Lucille Kempton.)

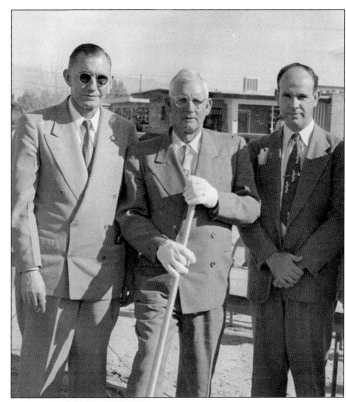

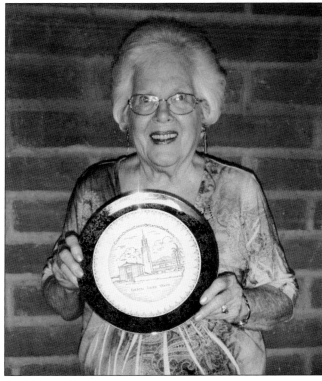

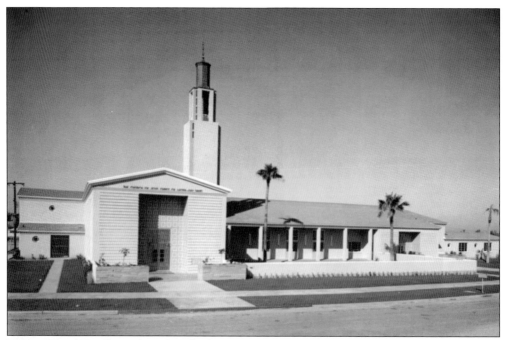

Tucson Third Ward members found other creative ways to raise money for their new building. Rulon Goodman invited colleagues and close friends to a swimming party, but his daughter Joyce McRae writes that "upon getting out of the pool, no one could find their clothes. Rulon invited them all to come to an auction. The items to be auctioned off were the clothes!" Vern Busby was the bishop and, "on more than one occasion, Vern would ask Rulon to pick up a load of building materials and when Rulon would have the loaded truck ready to go, he would find that he had to pay for the materials before he could leave." The Tucson Third Ward building (exterior above; interior of the recreation hall below) was finished in 1955. (Both, Joyce McRae.)

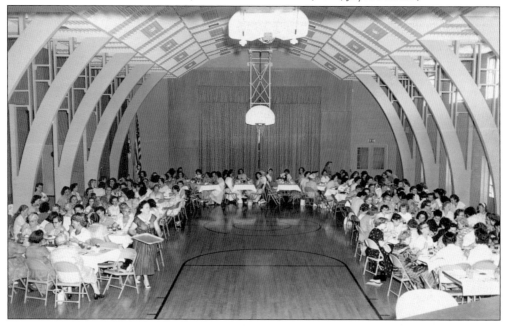

Tucson Second Ward also found creative ways to pay for their building. There were bazaars with donated handmade articles that were then purchased by the members. Such bazaars could earn from $2,000 to $3,000 in an evening. In 1952, the members also began holding quarterly building-fund dinners. At right, Bishop Richard Martin cooks at one of the barbecues. Below, Martin works on the building wearing patched pants made by ward members. Underneath each patch is money to be used for the new church. Also, the two wards produced yearbooks that they sold as fundraisers, but which have now become valuable pieces of history. (Right, Kenneth Rey Haymore; below, Jeanette Done.)

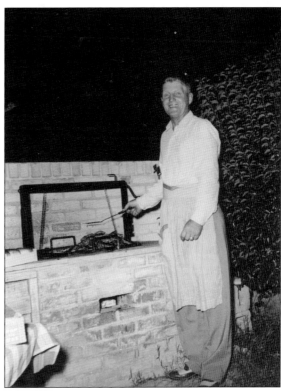

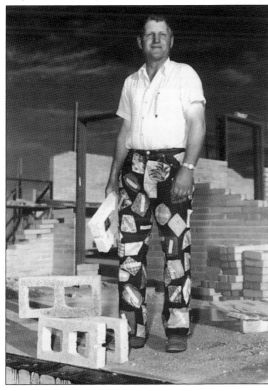

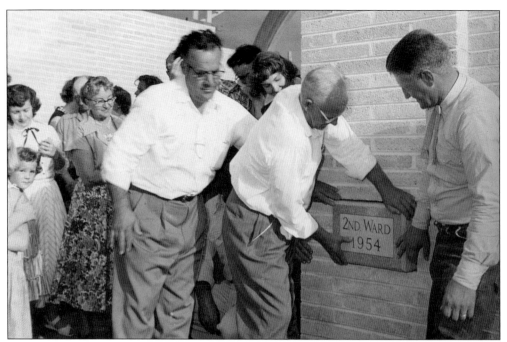

In the 1950s, wards provided 30 percent of the cost of buildings, some of which could be donated labor. At the time of the 24th of July celebration in 1954, the Linden Street building was far enough along that a decorative cornerstone was laid. Above are, from left to right, Mark Gardner, Stake President Jared Trejo, and Bishop Richard Martin. That same day, members met for a Pioneer Day program in their partially completed building (below). With July being monsoon season, "a good drenching" accompanied the meeting. The Tucson Second Ward building was completed in September 1956 at a cost of $145,982, including 18,610 hours of labor donated by members. (Both, Kenneth Rey Haymore.)

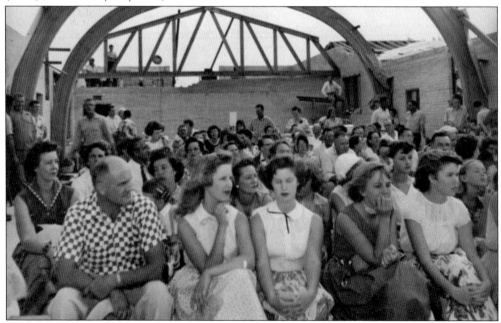

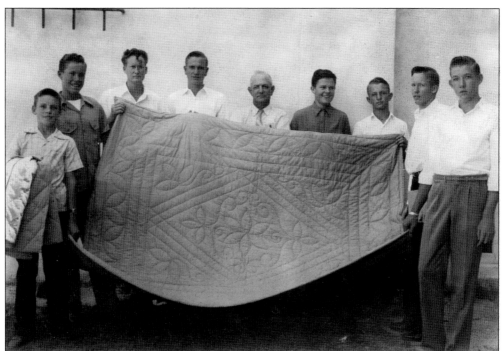

Latter-day Saints have always given service. In 1944, young men from the Binghampton Ward made a quilt for a needy family. Although some have suggested that the boys did not actually do the quilting, the widely spaced stitching seems to lend credence to their handiwork. Posing with the quilt above are, from left to right, Bobby Echols, Nelvin Stock, Ronal Young, Maurice Jones, Bishop Frank Webb, Joe Stock, Wayne Nelson, "Red" Nelson, and Richard Done. (Jean Webb.)

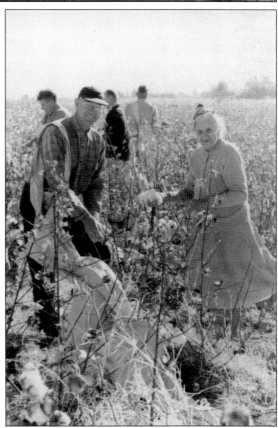

Since the Great Depression, church farms have been part of the welfare program. In 1949, a total of 11 acres were purchased in Binghampton from Junius Evans, land that eventually became a softball field and family park. Later, regular farm acreage was purchased in Marana. Crops have included cotton, wheat, grain sorghum, pecans, alfalfa, barley, and silage, and many volunteer hours have been donated. Richard Done and his mother, Louisa, are seen here picking cotton. (Jeanette Done.)

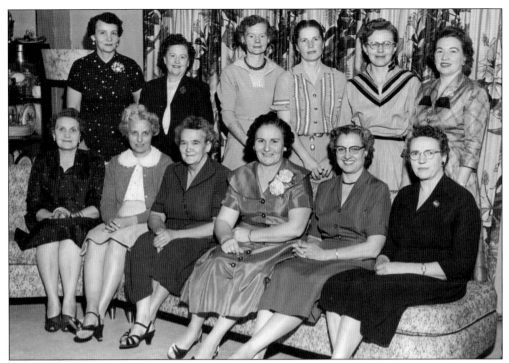

In 1956, Avez Goodman was the first Relief Society president of the newly created Tucson Stake. These photographs of the women who worked with her illustrate the wide variety of lessons and activities provided for LDS women. Above, from left to right, are (first row) Lola Killpack, visiting teaching message leader; Virginia Swanson, organist; Rose Clifford, work (handiwork and service) counselor; Avez Goodman, president; Nina Brewer, education counselor; and Zina Skaggs, social science leader; (second row) Veda Blain, work director; Ethel Clawson, theology leader; Joan Cornia, secretary; Belva Jones, magazine representative; Jean Dees, chorister; and Louise Call, literature leader. Below, the Singing Mothers, with their traditional white shirts and red flowers, provided music for the Tucson Stake conference in June 1958. Chorister Jean Dees is second from left. (Both, Joyce McRae.)

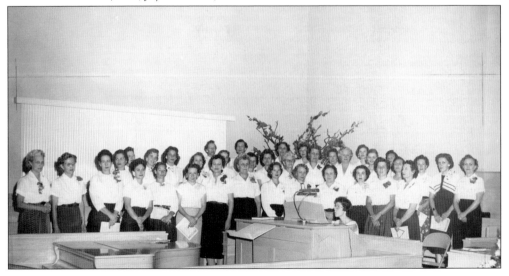

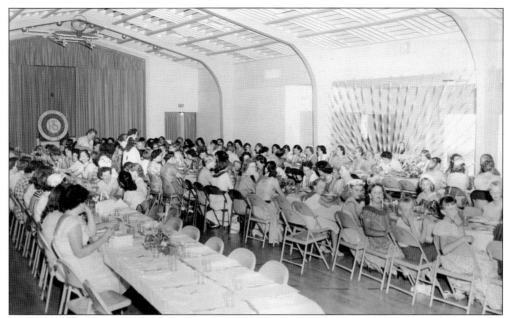

Every March, LDS women throughout the world hold a Relief Society birthday dinner celebrating the March 17, 1842, founding of this woman's organization in Nauvoo, Illinois. Sometimes, a luncheon is provided, like the one seen above in the Linden Building about 1958. Creativity and ingenuity often provided novel ways to review Relief Society history. The group of young girls below, enlisted to help with the program, includes, from left to right, (first row) Ramona Goodman, Yolanda Mitchell, Marilyn Busby, Loraine Mitchell, Cathy Busby, and Doris Lemmon; (second row) Mona Brown, Myrna Brewer, Janell Smith, Margaret Miller, unidentified, Ruth Reneer, and Kathy Hardy. They are dressed in their mothers' clothing for a skit—it is assumed that Mona Brown represents the bishop. (Both, Joyce McRae.)

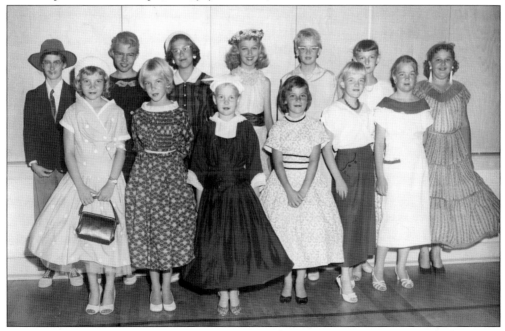

In 1952, women dressed as each of the past Relief Society presidents. Lucy Mortensen portrayed Emmeline B. Wells, who became the organization's fifth president in 1910. Wells chose the motto, "Charity never faileth," and helped supervise relief work during World War I, including arranging the sale of Relief Society wheat to the US government. (Joyce McRae.)

Eathel Busby wrote, "Papa and Mama [Alfred and Lucy Mortensen] were both singers and taught their children to sing. Papa was never too tired to take us on his lap after a hard day's work and sing the old songs we loved so much." As adults, Eathel (right) sang alto, while her twin, Ethel, sang soprano. Their nephew Tanner Brown is in the center. (Photograph by Larry W. Sellers, Joyce McRae.)

Ideally, every Latter-day Saint woman receives a visit in her home every month by two Relief Society women. The welfare of the family is noted and gospel principles are discussed. Often, these visiting teachers are honored for their service in a yearly meeting. Above (from left to right), Clara Busby, age 80; Agnes Watson, 91; and Louisa Done, 88, were so honored in 1957. It was noted that Busby traveled 100 miles round-trip each month to visit her sisters. The next year, a luncheon and program was provided for all visiting teachers in the Tucson Stake, and each woman over 75 was presented with a corsage. Below, from left to right, are Carolina Phelps, Louisa Done, Elsenor Nelson, Agnes Watson, Lucy Mortensen, and Bessie Mincher. (Both, Joyce McRae.)

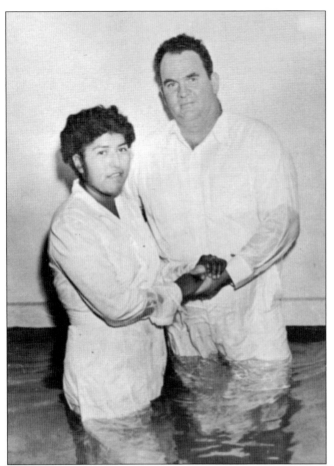

Latter-day Saints have always proselytized among Native Americans. Seen at left is the first Papago (Tohono O'odham) baptism, as Jeanette Palimo is baptized by Dorrity Busby. Below are the attendees of the baptism. From left to right, they are (first row) Vance Goodman, Vern Busby, Thelma Harris, Jeanette Palimo, Ramona Garcia, Eleanor Shipley, Henrietta Shipley (girl), and Lucille Palimo; (second row) Kelton Harris, ? McGee, Sophia Taylor, William Luke, Dorrity Busby, Shirley Busby, and Kenneth Haymore. Presumably, Sisters McGee and Taylor were the missionaries who taught Palimo. In the late 1940s and early 1950s, Mary Stough taught a Primary class in Pascua Village, south of Tucson. Today, a small group of members continues to meet at Sells. (Both, *Memories*, 1955.)

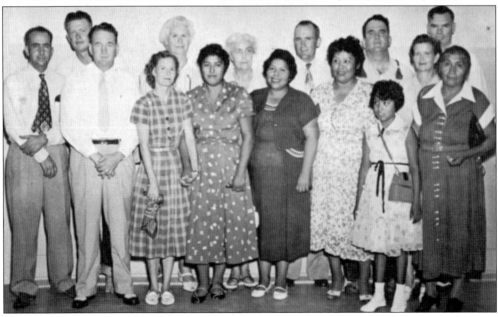

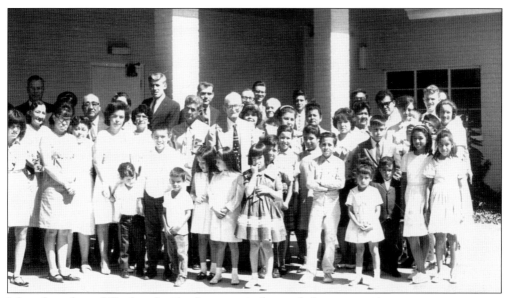

It has always been difficult to decide when to assimilate and when to provide separate congregations for non-English-speaking members. In 1960, the Spanish-American Branch began meeting at the Linden chapel. This photograph was taken between 1965 and 1967, when Kenneth Haymore (back, far left) was president. Prior missionary languages were often an asset. Haymore served a mission in Mexico from 1923 to 1926. (Kenneth Rey Haymore.)

In 1965, the motion picture department at Brigham Young University produced the film *And Should We Die* about Rafael Monroy and Vicente Morales during the Mexican Revolution. Old Tucson was used for the location, and members of the Spanish Branch were used as extras. Monroy and Morales were converts of Ernest Young and Willard Huish in central Mexico; their July 17, 1915, execution became a story of religious martyrdom. (Wayne Goodman.)

Lee Jones (left) wrote, "My family moved to Binghampton in 1924 when I was 19 years old. I was soon put to work as Scoutmaster of Troop 3. Most of the boys in the troop were good Mormon kids but 'tougher than a corn cob.' I had a hard time trying to convert them to scouting." Jones was a Scoutmaster for 17 years and later a bishop. Below, Jones and his Scouts have a shield listing values in the Scout Motto: "A Scout is trustworthy, . . . brave, clean, and reverent." The Scouts went hiking at the Grand Canyon, on Mount Baldy, and, of course, in Sabino Canyon. (Left, Gerald Jones; below, Jean Webb.)

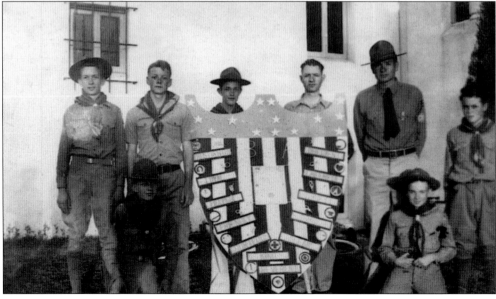

With gold and green the official colors for the Mutual Improvement Association, the first Gold and Green Ball was held in Utah in 1922. This dance soon became a part of each Mormon community, including Tucson, complete with a king and queen (left, Lolene Killpack and Maurice Busby) and chaperones (right, Nina and Leslie Brewer). (Both, Lucille Kempton.)

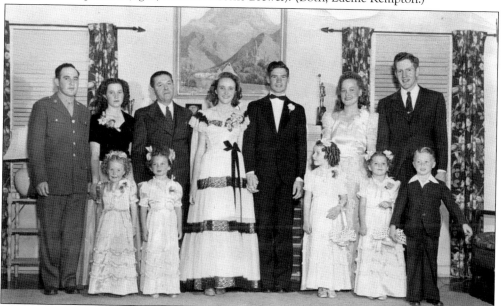

The king and queen for this 1944 Gold and Green Ball were Kenneth Haymore and Beverly Maxwell. Seen here, from left to right, are LeRoy Lemmon, who was home on leave, unidentified, Gordon Kimball, Beverly Maxwell, Kenneth Haymore, Laverna Haymore, and unidentified, with unidentified children. Wilford Maxwell, Beverly's father, made his fortune selling sandwiches to troops passing through Tucson on the train. (Kenneth Rey Haymore.)

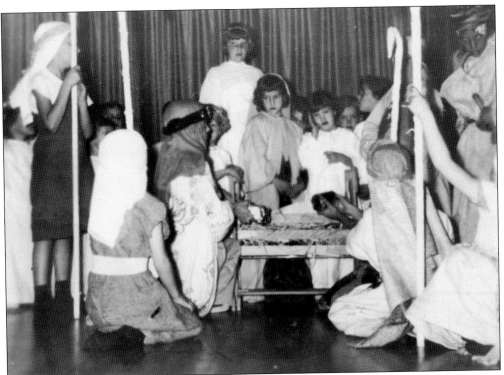

These two photographs are from a 1950s *History of the Second Ward Primary*. Above is a Christmas manger scene. Below are two entries from a 24th of July parade, with Faye Bristol as the primary teacher sitting in front of the scripture, "And they shall also teach their children to pray, and to walk uprightly before the Lord" (D&C 68:28). To the right are the 10-year-old Bluebird girls. On their bandelos, starting at the bottom, are a pink home, a white temple, a red-winged foot, a yellow lantern, and a bluebird. Each symbol represents goals the girls had accomplished. (Both, Marcia Claridge.)

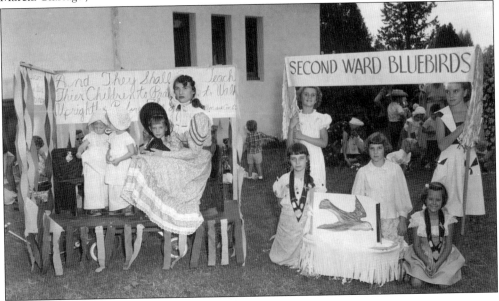

No group of photographs of LDS congregations would be complete without a picture of missionaries. Missionaries came to Tucson, and Tucson members have sent their own sons and daughters on missions. Charles Hardy (left) of Tucson is seen here with his missionary companion, Chester Lewis, in 1928. After their missions, Lewis convinced Hardy to move to Winslow. Lewis is best known for building the Wigwam Motel in Holbrook. (Renee Hughes.)

Sharon Reneer Shields played the organ for the dedication of the Third Ward chapel and also for the rededication of the Arizona Temple in 1975. She told the *Church News*, "I planned it so that when President Kimball came into the room, I would play 'I Am a Child of God.' " Shields's grandfather Harry L. Payne was the president of the Arizona Temple from 1944 to 1953. (USHS C-330.6.)

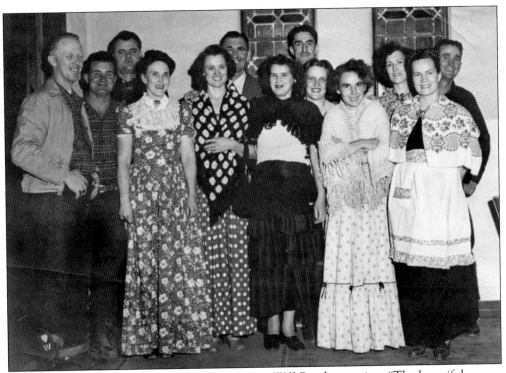

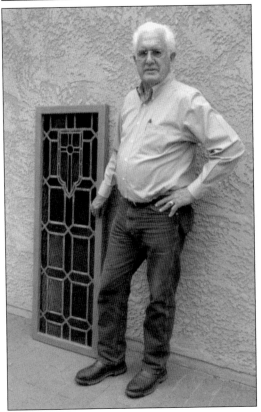

Will Bingham writes, "The beautiful stained glass picture of Jesus in Gethsemane is first in our memory of our life and times growing up in Binghampton." *Christ in Gethsemane*, by Heinrich Hofmann, is believed to be one of the most copied paintings in the world. There were also four stained-glass windows on each side of the chapel, which were replaced during remodeling. Above, a group of young adults in pioneer dress stands in front of these windows. From left to right, they are Vernon Thurgood, Morse Holladay, Reid Dees, Ometa Atkins, Nina and Leslie Brewer, Garna Taylor, Reid Ellsworth and his wife, Gertrude Post, Hannah Farnsworth, Thelma Goldstein, and Joe Farnsworth. At left, Duane Bingham salvaged one of the windows and plans to incorporate it into his home. (Above, Lucille Kempton.)

Four

THE TUCSON INSTITUTE AT 75

In 1885, the 13th Arizona Legislature was to convene in Prescott and decide locations of various institutions in the Arizona Territory. Competition between the larger cities was keen. Tucson especially wanted the capitol, so its citizens raised $5,000 toward that end and sent a delegation to Prescott. Inclement winter weather, however, delayed the men, and first prize, the capitol, had already been given to Prescott. Second prize, the prison, had been awarded to Yuma, and third prize, the insane asylum, was to be in Phoenix. Tucson lawyer C.C. Stephens did not want to return home empty-handed, so he supported the proposition that the normal (teachers') school would be in Tempe and the university in Tucson. Historian C.L. Sonnichsen said that the university was initially "unwelcome, undervalued, and resented," especially by Tucson merchants. When Stephens tried to explain his actions, he was met with personal abuse, profane language, and rotten eggs and vegetables. According to Mose Drachman, local sentiment was expressed by a bartender, "What do we want with a university? Who ever heard of a University Professor buying a drink?" The first building was not completed until 1891.

Latter-day Saints have always been encouraged to obtain as much education as possible. However, the trip to Tucson from settlements along the Little Colorado River in northern Arizona was so difficult that many early students chose to attend Brigham Young University in Provo, Utah, rather than the University of Arizona in Tucson. Besides, at Provo, there was a greater possibility of finding a marriage partner of the same religion. Students could also pass the teacher's examination with classes from normal schools in Tempe and Flagstaff. The first LDS students to attend the University of Arizona came about 1912.

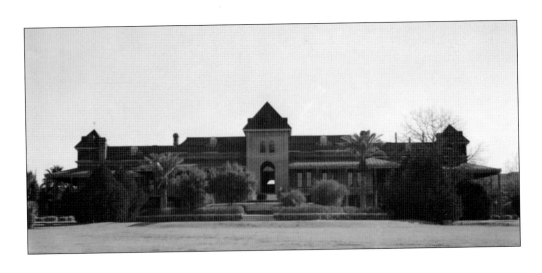

The University of Arizona (Old Main, above, in 1938) had three things unique in Arizona: a law school, the agricultural extension service, and a school of mines. One of the first Latter-day Saints to attend the university was Charles Fillerup. He graduated from Brigham Young Academy in 1895 and then taught school in Colonia Díaz, Mexico. In 1912, he fled with his family to Hatchita, New Mexico, worked for a short time at Tucson Farms, and then attended the university from January to August 1913. He is seen below standing on the far right with agriculture classmates and Dr. Robert Forbes (far left). Fillerup became an important part of the Agricultural Extension system, first in Cochise County and then in Navajo and Apache Counties. (Both, Wanda Smith.)

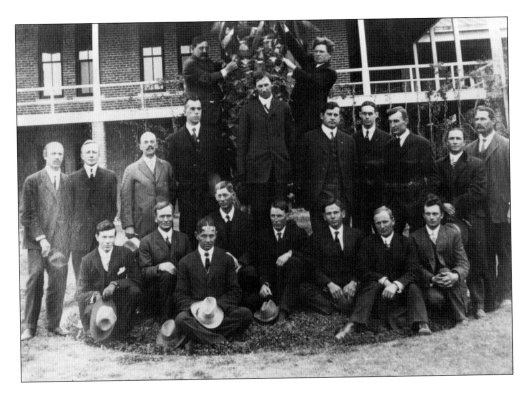

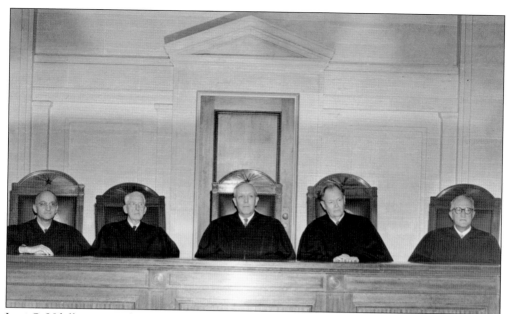

Levi S. Udall came to the University of Arizona in 1914 to study law. He did not graduate but passed the Arizona Bar exam in 1922 and had a distinguished career in Arizona's courts and in the church. He is seen here when he was chief justice of the Arizona Supreme Court in 1951. From left to right are Judges Evo DeConcini, Martin Phelps, Udall, Rawghlie C. Stanford, and Arthur T. LaPrade. The University of Arizona awarded Udall an honorary Doctor of Laws degree in 1960. (ASLAPR, 01-4621).

Spencer W. Kimball graduated from the Gila Academy in 1914 and planned to attend the university. Instead, he was called on a mission. He did come for one semester in 1917, but further schooling was interrupted by the draft and a young woman, Camilla Eyring. Many in Tucson remembered him fondly when he became president of the church. He is seen on the left at the rededication of the Arizona Temple in 1975. (USHS, C-330.9.)

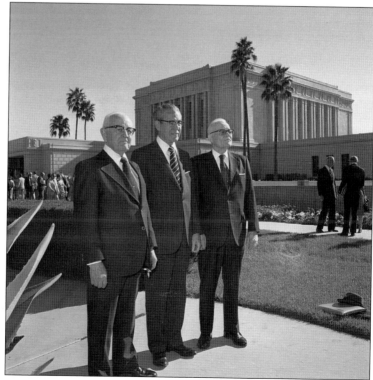

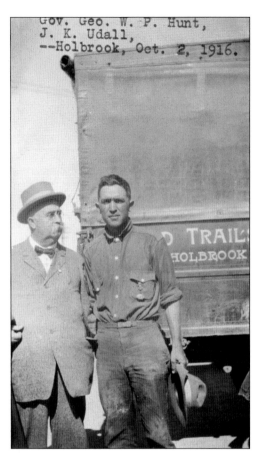

Gov. Geo. W. P. Hunt,
J. K. Udall,
--Holbrook, Oct. 2, 1916.

Jesse A. Udall came to the university in 1914, but his schooling was interrupted by World War I, where he served as an ambulance driver in France. He graduated from the University of Arizona Law School in 1924, established a private practice in Safford, and was instrumental in setting up a National Guard unit there. He served as both stake and mission president and on the Arizona Supreme Court. (ASLAPR, 02-3074.)

Eathel and Ethel Mortensen graduated from high school in Virdin, New Mexico, and then chose to come to the University of Arizona in 1935. They are seen here standing in the doorway of Old Main. They joined the oratorio society and sang the *Messiah* at Christmas and *Tannhäuser* in the spring. They took violin lessons, which, Eathel said, "helped us perfect our fingering in precise positions." (Dolores Bingham.)

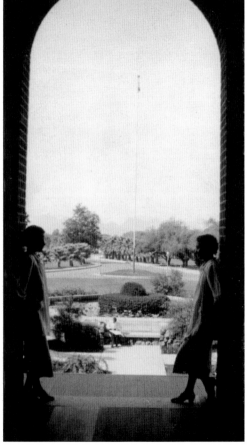

Alando B. Ballantyne (right), a prominent church leader in Tucson who had earlier been a county extension agent for Cochise County and taught agriculture classes at the University of Arizona in 1936, recognized the unmet needs of LDS students. He began a correspondence with Franklin L. West, and a site north of campus at Mountain Avenue was purchased. Construction began immediately, and the Tucson Institute of Religion (below, in 1941) was dedicated on November 7, 1937. The first director, Lowell Bennion, writes, "The University of Arizona was a sophisticated school with high quality students. Many of them came from out of state to attend the law school. Most of the L.D.S. students attending the university had a rough time financially and had very little pride and unity as a group. They found a new status on campus with the establishment of the institute." (Right, AHS/Tucson 11618; below, photograph by Max R. Hunt.)

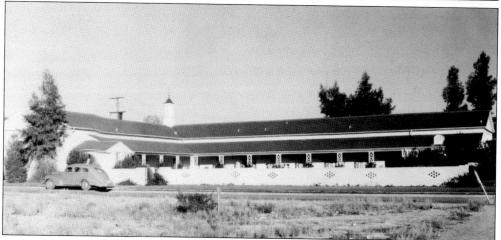

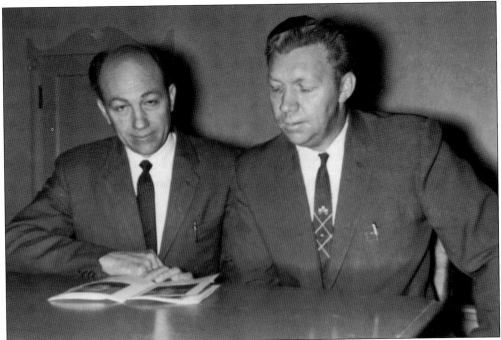

Marion Smith wrote, "Dr. Bennion [left, with Clyde Davis in 1960] was a superb teacher, a highly educated historian, and commanded the respect of all who knew him. He had a most pleasing personality and a great testimony of the Restored Gospel of Jesus Christ, of the Prophet Joseph Smith, and of the Book of Mormon." Bennion said, "The building created a good image for the Church." (Sharon Bingham.)

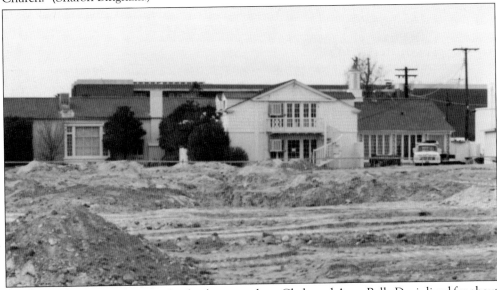

The institute had an apartment for the director, where Clyde and AnnaBelle Davis lived for about six years. Davis wrote, "Living above the Institute the children had to learn to sleep in spite of patio volleyball games, click-clicking ping-pong balls, and disturbing dance music. Our kitchen was constantly invaded by students looking for food or utensils. Our car was frequently borrowed, and our privacy was never certain." (TIR.)

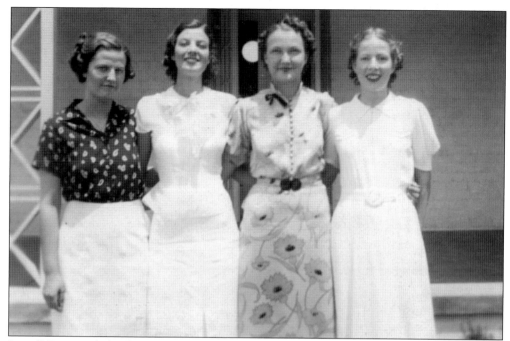

Lowell Bennion helped establish the first LDS sorority, Lambda Delta Sigma, in Salt Lake City in 1936, followed by a Tucson chapter in 1937. With candles and flowers, 22 girls met for the organizational meeting. They elected Ruth Isom (above, left) as treasurer and, from left to right, Maybeth Farr as secretary, Grace Naylor as vice president, and Regina Brinkerhoff as president. Because it became a sorority-fraternity, they could not participate in intramural activities on the university campus, but they sponsored many dances at the institute, including the April Fool's Day dance below in 1939. The invitation reads, "? celebration first April an in corps infant Sigma Delta Lambda the join and suit kiddie little favorite your on put please you won't," which is to be read backwards. (Both, TIR.)

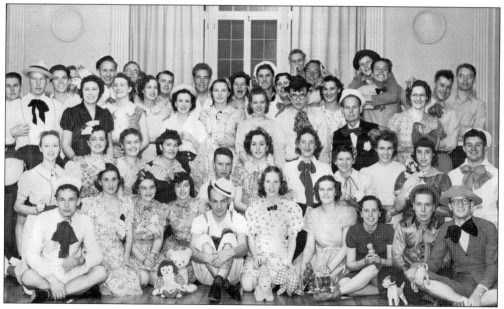

The Tucson Institute was the first religious building associated with the University of Arizona. Institute facilities were in constant demand from church, civic, and school groups. With a recreation hall and a chapel seating about 200 people, the institute hosted meetings for Jews, Quakers, Methodists, and the First Church of Christ. The 1942 group above appears to be a wedding party. Some of the women attending this event were photographed separately. They include, below, from left to right, Clara Kimball, Anona Haymore, Rowena Holladay, Ethel Clawson, three unidentified women, Blanche Smith (?), and Annie Ballantyne. (Both, Kenneth Rey Haymore.)

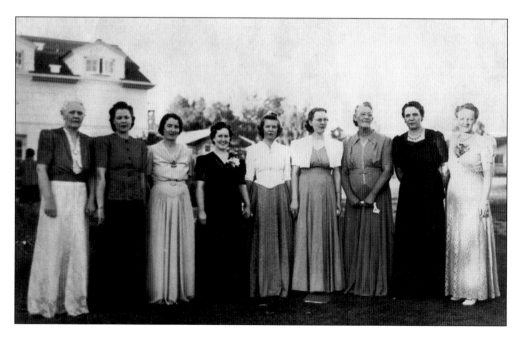

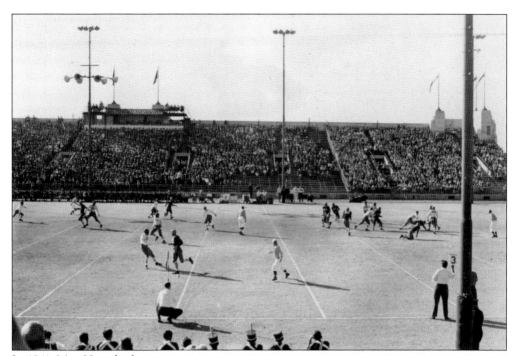

In 1941, Max Hunt had just returned from an East German/Southern States Mission and was living with his aunt, Blanche Smith, while attending the University of Arizona. With 78 LDS students in 1940 and 131 in 1941, institute personnel struggled to meet the needs of these men. Activities that fall included trips to the Saguaro National Monument and to San Xavier, interspersed between classes and football games—in the game above, Arizona beat Kansas State 28-21. Then Pearl Harbor was bombed on December 7, 1941. Every newsboy around the nation was selling papers with headlines announcing the news, including the boy at right in downtown Tucson. The world changed overnight for students and for Tucson's LDS community. (Both, photograph by Max R. Hunt.)

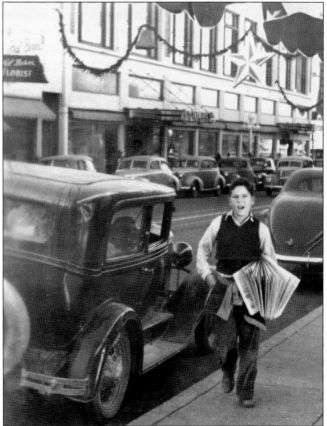

People across the nation sent newsletters to their servicemen. The institute called its *Bits from Half-Wits*, and the October 1944 edition includes this note titled "On the Riviera": "Ernest Clawson is somewhere in southern France and is still attached to the hospital unit which he served with in North Africa." Clawson in turn sent them his photograph (left). He returned to Tucson, married Laverna Haymore, and later set up a maternity hospital in Snowflake. The same newsletter reports "the latest news about the four Lemmon brothers. George [below] graduates the 25th of this month from his V-12 unit at Albuquerque; LeRoy is spending his furloughs in merry Scotland; Bob is aboard his ship so can't say much; and Wayne was awarded the purple heart in France where he received a shrapnel wound in the arm." (Both, TIR.)

The Binghampton Ward also produced a newsletter, the *Stringtown Toot*, which printed 190 copies at its peak. Its June 17, 1944, issue reports, "Erma Evans is flying small planes such as Cubs and Taylor Crafts at the Gilpin airport. She plans to join the WASP when she receives her wings." Evans eventually became a "riveter" at the shipyard in Long Beach, California, and said, "I would burn 40 lbs. of rod on some nights." (Duane Bingham.)

The July 1, 1944, the *Stringtown Toot* reports that "Belton Palmer has been promoted to corporal in the Marine Corps." The Army tried to separate brothers so they would not have to report two deaths to a family, but Belton (below, left) and Duffy Palmer fought to stay together. They are seen here in Alaska. Duffy was shot in the neck at Iwo Jima and only survived because Belton administered first aid. (Renee Hughes.)

SERVICE MEN

Charles Anderson	Dean Howell	Marion Plumb
Spencer Andrews	Melvin Huber	William Pomeroy
Thomas Ballantyne	Carl Huish	William Flake
Joseph Dean Bennett	Bruce Hunt	Ted Foreman
Neil Bargquist	Leonard Isaacson	Grant Layton
Jack Bowen	Kenneth Jarvis	Roscoe Rogers
Gordon Brown	John Jennings	William Rommey
Orson Cardon	William Jennings Jr.	Raymond Roseboro
Eldon Clawson	Winn Jensen	Rulon Gene Shelley
Ernest Clawson	Vard Johnson	George E. Shelley
Kemp CDifford	Myles Jones	Melvin Shelley
Willis Reid Dees	Stanley Julian	Samuel Skousen
Melvin Denham	George Lemmon	Keith Sohm
Guy Driggs	Leroy Lemmon	Wayne Solve
Grant Ellsworth	Clyde Loving	Gail Standage
James Ferrin	Rud Mack	Lacy Thomas
Gerald Fuller	Harold Miller	John Tucker
Malcolm Greer	Lloyd Miller Jr.	Addison Udell
Dean Griner	Wesley McCartney	Calvin Udall
Ralph Hansen	Howard Millett	Morris Udall
Robert Hansen	Keith Millett	Wendell Udall
Floyd Haupt	Meade Nielson	Warren Whiting
Arbon Heap	Charley Patterson	Milo Willis
Joseph Holt	Gerald Plumb	James Wiltbank

Girls at the institute made this list of LDS servicemen. On the opposite page is a letter they received in response. (TIR.)

22 Nov, 1944

Dear fellows + gals —
I was sure happy to receive the little news-paper from you, and get in on a little of the news. It's good to know that things are going swell at the Institute. It would be swell to be back there and enjoy some of the dances, and parties, and so forth with you all. Of course right now I've got a job, along with lots of other guys to do a little fighting. I'm flying as a bombardier-navigator on a B-24. To date all my missions but one has been deep in the heart of Germany. I haven't run across any fellows from home or from the U of A.

The letter continues: "I'm very lucky to be stationed on this base as there are a group of L.D.S. boys here and we all get together and hold a church service each week. There is also a church in the town near where I'm stationed. I noticed there were quite a few new names in your group at the Institute. That's to be expected though, because it's been nearly two years since I left the U of A for the army. Well, I'd better close now. Thanks again for the news. By the way, In case you don't know, I married [Sine Scharling while in Idaho] and naturally I'm the luckiest guy in the world to have the most wonderful wife in the world. I'd better run along for use, because I've got to do a little flying tonight. Sincerely, Ernest Post."

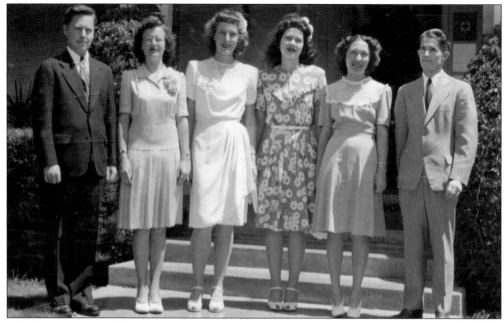

For the 1946–1947 school year, Harold "Hal" Goodman of Duncan (right, with Ernest Clawson and unidentified girls) was elected the university's student body president. His major was music education, with emphasis on the violin and trumpet. Stewart Udall was president of the Bobcats, the athletic booster club, and the student bar association. Homecoming that year honored World War II dead. (TIR.)

Lambda Delta Sigma was recognized by the university only as a student club, because it had no fraternity house and it was coeducational. In 1957, the young men officially separated, and the Lambda Delta fraternity was organized, as members said, "to have missionary opportunities rather than to create a Greek social unit." The young men are seen here with Elder Hugh B. Brown (front, center). (TIR.)

In 1956, Frances Nickerson (right) was elected homecoming queen at the University of Arizona. Lambda Delta Sigma members always sponsored a homecoming float, and won first prize with their 1956 entry (below). Clyde Davis wrote that "some student would bring in forty or fifty pounds of deer meat and we'd grind it up into hamburger. We mixed in a little bit of pork, and then we'd always fry it up for a Hamburger Fry while we were building floats for homecoming. Most of the kids didn't know what they were eating, but they were hungry enough and they'd eat it all within two nights." In 1959, there were 210 students enrolled at the institute—78 percent of the LDS students at the university. (Both, TIR.)

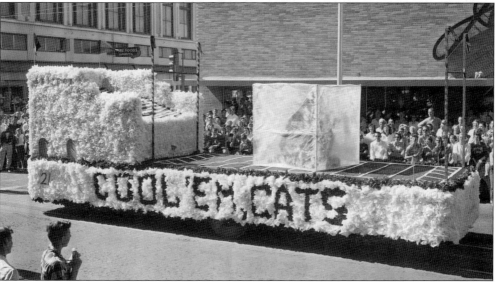

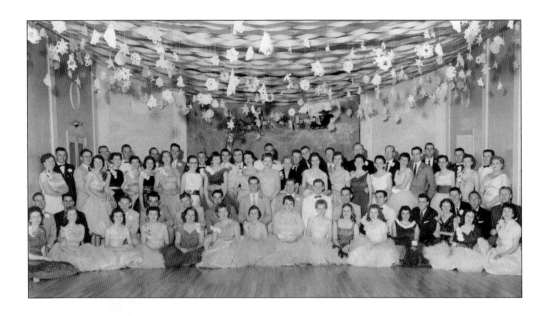

Director Clyde Davis and his wife, AnnaBelle, were loved by the students of the institute. Students saw LDS family life up close, particularly when the Davises' son, Steven, suffered head injuries during a hunting accident and spent several months recovering. The Davises were also willing chaperones for dances. Above is a Christmas formal on December 11, 1957, sponsored by Lambda Delta Sigma. The blue-and-white snowflake ceiling provided decorations for a "'Twas the Night Before Christmas" theme, and Merle Webb's orchestra provided the music. Another formal dance held in 1956 is below. The Davises are seen above, in the lower right corner, and below, standing and seated on the far left. (Both, TIR.)

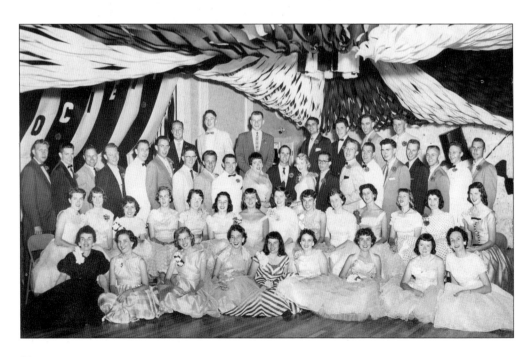

Institute personnel sometimes taught high school seminary and were always involved with Sunday School and MIA for university students. Clyde Davis was the president of the pastor's fellowship for five of the 12 years he was in Tucson. The first student ward was established on February 17, 1959, with Leamon A. Reneer, a prominent attorney and the president of Tucson Title and Trust Company, as the first bishop. At right, from left to right, are Clyde and AnnaBelle Davis, Leamon and Helen Reneer, and institute teacher Hal Ferguson and his wife, in 1958–1959. After about four years, Davis was called as bishop, and he encouraged the creation of a separate married ward. Below, from left to right, are seminary/institute instructor Melvin and Mildred Rogers, the Davises, the Reneers, and Faye and Cleone Payne, in 1960. (Both, TIR.)

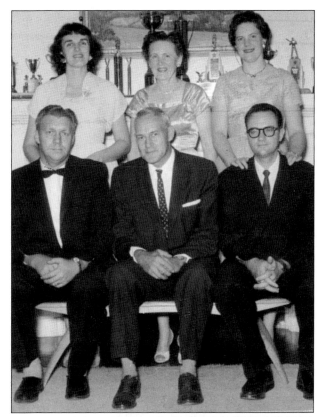

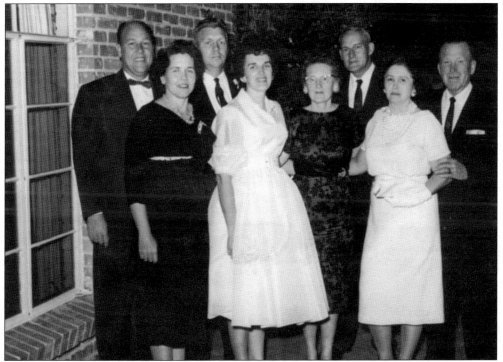

In the late 1950s, institute students participated in organized activities such as horseback riding, formals, western dances, picnics, baseball, football, and choir. In the winter, there were snow parties on Mount Lemmon, albeit sometimes without snow. Above, a group of young men, including Duane Bingham (second from left), carries a pot of chili beans to the activity at the church cabin on Mount Lemmon. Below is a quartet that often sang together. They are, from left to right, "Rocky" Curtis, Kenneth Goodman, Elaine Brewer, and Deanne Merrill. In September 1956, the girls gave AnnaBelle Davis a baby shower, as she had just given birth to a baby girl two weeks before school started. Clyde Davis, who had given up a promising career with the Atomic Energy Commission, sometimes took young men prospecting. (Both, Sharon Bingham.)

Young men at the institute excelled in both academics and sports. Each year when rivals Arizona State University and the University of Arizona played football, a bike derby (relay) was held over the 110 miles between the two schools. In 1959, the Lambda Delta team won, riding in laps of from 8 to 13 miles per rider, completing the distance in six hours and 55 minutes. At right, Duane Bingham (left) and president Kenneth Goodman accept the trophy. Below, a later president of Lambda Delta, Kenny Evans (left, with vice president Benny Riggs), receives the Scholastic Achievement Award from Robert Schmalfeld (center), the dean of men, in 1964–1965. The grades the young men at the fraternity earned were "Above All Men's Average." (Right, Sharon Bingham; below, TIR.)

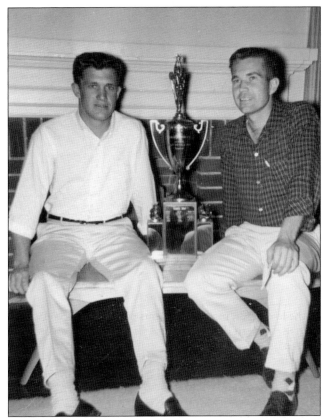

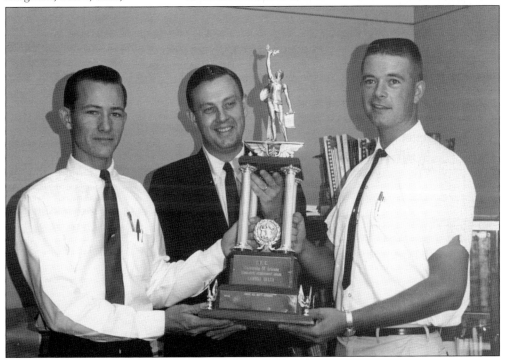

Paul E. Dahl arrived in Tucson to become the new institute director in the summer of 1969. He was just finishing his dissertation on the life of William Clayton, and in 1981, he was asked to contribute an article to an edition of *BYU Studies* that discussed the church in Iowa. The final title of the article: " 'All is Well . . .': The Story of 'the Hymn that Went Around the World.' " (John Dahl.)

The institute had several young female secretaries in a row. Dahl finally wrote a letter to the stake Relief Society presidents asking for a "mature" sister. Ethel Goodman, a widow and the president of the Tucson Stake Relief Society, applied. Dahl said that she "was an answer to my prayers. She had the personality and maturity for an institute secretary." She also knew shorthand. (Dolores Bingham.)

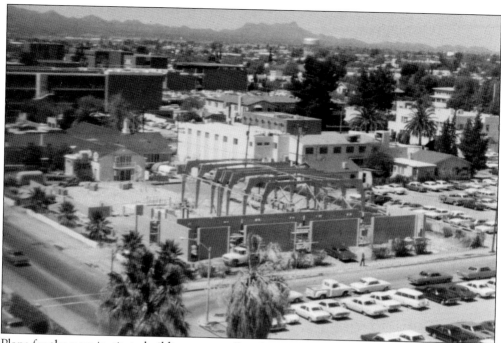

Plans for the new institute building were well underway when Dahl arrived. Ground-breaking ceremonies took place on December 3, 1969. The *Arizona Daily Wildcat* laments that a faculty parking lot leased by the university was being sacrificed for the new building. On October 12, 1970, students, faculty, and custodial staff moved furnishings from the old building to the new, and classes began in the new building the next day. The old building (below) was then razed and a parking lot put in its place. The new institute building was dedicated on April 25, 1971, by Elder Delbert L. Stapley, a beloved apostle originally from Mesa. Marvin D. "Swede" Johnson represented the University of Arizona at the dedication. (Both, TIR.)

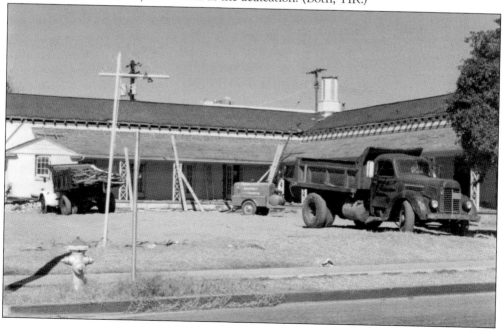

In 1970, a nationwide "discourse" began about African Americans and the LDS Church. The *Arizona Daily Wildcat* published articles, and when the BYU basketball team played in Tucson, nine students attempted to stop the game. Another demonstration was planned around the institute, but when Dahl received public media support from university administrators, the few picketers were peaceful. Bruce Larson (left) was the coach of the varsity basketball team and also the bishop of a student ward. Dahl wrote, "Probably no individual in the Church was found in a more difficult situation than was Bishop/Coach Larson during those trying months." In the fall of 1971, student leaders from the University of Arizona visited BYU's campus, and the football game was played without incident (below). On June 8, 1978, Official Declaration–2 was issued, offering priesthood and temple blessings to all races. (Left, Jeanette Done; below, *Tucson Daily Citizen*, October 10, 1971.)

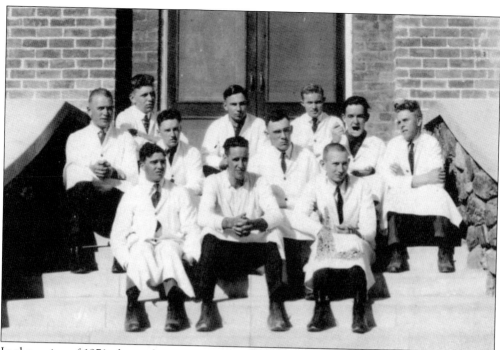

In the spring of 1971, the student association wanted to establish a guest lecture series. It decided to name the series after Henry Eyring, a University of Arizona alumnus. Eyring, seen above in the center of the third row with classmates in 1921, was the dean of the graduate school at the University of Utah and a world-renowned chemist. He is seen at right at Kyoto University in 1963. He was influential in the church and in the scientific community, authoring more than 600 scientific articles and 10 books, plus religious works including *The Faith of a Scientist*. Dr. Eyring said, as reported by Steven H. Heath in a University of Utah MS thesis, "The church is committed to the truth whatever its source and each man is asked to seek it out honestly and prayerfully. . . . The author has never felt the least constraints in investigating any matter strictly on its merits." (Both, University of Utah, UU_P0250, 478 and 724.)

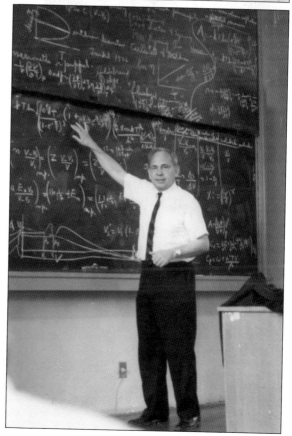

Another speaker that first year was astronaut Don L. Lind from Murray, Utah (center, in 1973). Lind was a personal friend of the Dahl family; his mother had been one of Pres. Paul Dahl's Primary teachers. Lind flew to Tucson in a small NASA jet and stayed in the Dahl home. When eight-year-old John Dahl told his schoolmates that he had sat in a NASA jet and that an astronaut was staying at his house, he was reprimanded by the teacher for his wild imagination. An autographed photograph with a personal message later convinced the teacher that John was telling the truth. Some early speakers included Hartman Rector Jr., Hugh Nibley, Stephen R. Covey, Paul H. Dunn, and Neal A. Maxwell. This lecture series continued until 1985, when it was replaced with "Know Your Religion."

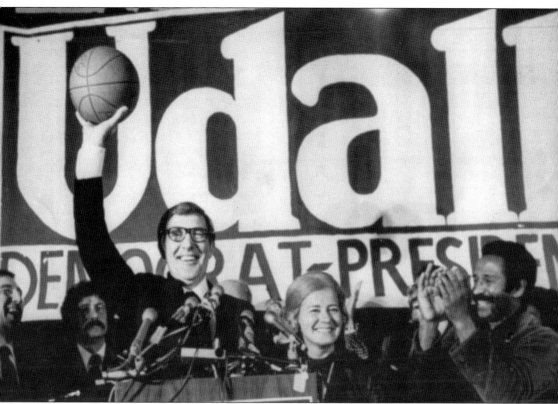

Morris "Mo" and Stewart Udall were both students at the University of Arizona. Although they were probably only culturally Mormon, they actively participated in institute activities. Marion Smith remembered that in 1938, he and Morris "worked a couple of Saturdays side by side doing pick and shovel work and loading dump trucks with caliche, preparatory to putting in a beautiful lawn area to the south of the Institute." The Udalls attended law school and played basketball for the university. Mo even played professional basketball for the Denver Nuggets in 1948. During World War II, Stewart completed 50 missions as a gunner on a B-24 in Italy and had time to visit some of the famous cities of Italy. In later years, both brothers became prominent politicians. Stewart served as the secretary of the interior under Lyndon B. Johnson, and Morris represented Arizona in Congress for 30 years. Both men returned to address institute students. Seen here is a press release photograph from Mo's 1976 run for the Democratic nomination for president.

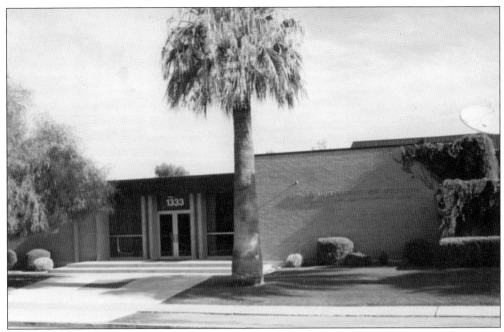

The new institute building (above) still serves University of Arizona students from across the United States. Students still participate in both institute and university activities; the homecoming float for 1967 (below), with green frogs and a reference to marriage, is one example. A headline in the *Church News* in July 2010 reads, "Tucson Institute—An Island in the Midst of the University of Arizona." The article compares the institute to the Steward Observatory Mirror Lab on campus and says, "People across the globe use the mirrors made on the campus . . . to gaze far into the heavens." Norman Gardner, the director of the institute, says, "That is what we do at the Institute. We feel like our job is to help point young people toward spiritual things We want them to see with a clearer view." (Both, TIR.)

Five

IN THE COMMUNITY

In 1899, when Nephi Bingham and his brothers leased land north of the Rillito River, Tucson was a bustling city with a population of 7,500. It was the largest city in the Arizona Territory in part because communities in the Salt River Valley were still distinct. When a land grant college was established in 1894, Tucson began its transformation into a modern city. There were electric lights by 1895, and the 200-room Santa Rita Hotel was completed in 1904. Tucson's climate made the area a mecca for tuberculosis patients, and amenities at the Santa Rita Hotel made Tucson a favorite of out-of-town visitors.

The settlers at Binghampton found it was about six miles down a dusty road to Tucson. Old Fort Lowell, on the other hand, was close by, and census entries always list the Binghampton area as Fort Lowell. By 1912, when Latter-day Saints fled revolutionary unrest in Mexico, Binghampton and Tucson became a haven where employment could be found and families could be raised. Latter-day Saints participated in nearly every aspect of the Greater Tucson community.

Today, Binghampton, Fort Lowell, Flowing Wells, and Jaynes Station have all become part of Tucson. In the Binghampton area, 427 acres was designated the Binghampton Rural Historic Landscape in 2003, and Brandi Fenton Memorial Park was created in 2005 to honor a 13-year-old who died in an automobile accident. Tucson Parks and Recreation has made this area a showplace for multiuse, with equestrian arenas, soccer fields, basketball courts, picnic areas, and dog runs. All the while, it remembers a historical farming community and pays tribute to a little girl who loved life and butterflies.

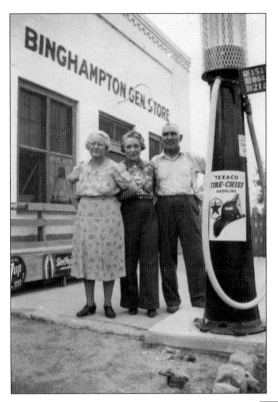

Binghampton General Store, on Fort Lowell Road, was opened in 1925 by Ephraim Tompkinson. It was later owned by Jake Bingham and then by the Anita and Napoleon Remily family, Catholics from South Dakota who came to Binghampton in the 1920s. Here, Lucy and Alfred Mortensen stand with their daughter Eva (center) next to the Texaco gas pump. (Dolores Bingham.)

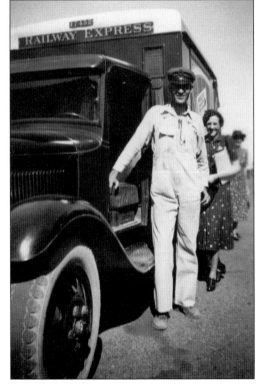

The railway, which included the Southern Pacific and later the El Paso and Southwestern Railroads, became one of the most important assets for the growth of the city of Tucson. Richard Done spent his entire career working for Railway Express, first delivering goods around town and later as a clerk. He is seen here with two unidentified women. (Jeanette Done.)

On September 13, 1924, Charles Manier, seen at right with his wife, Bessie, was out for a drive with his family and stopped at a limekiln on Silverbell Road. There, he "accidentally" found a massive iron cross in the caliche, which, along with later finds, became known as the Tucson Hoax (below). Some archaeologists and Mormons, however, believed the artifacts to be genuine. Manier made blueprints, which Eli Abegg and Gordon Kimball sent to Salt Lake City. Church leaders refused to become involved in the controversy, and church president Heber J. Grant wrote, "The plates which have been unearthed by you we think have no connection with the plates from which the Book of Mormon was translated." Hugh Nibley later wrote, "True knowledge never shuts the door on more knowledge, but zeal often does." (Right, Jim Bingham; below, drawing by Merlin Ellis.)

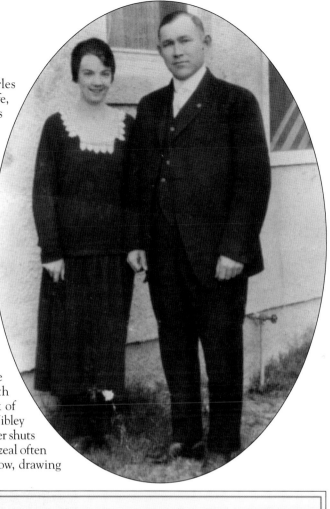

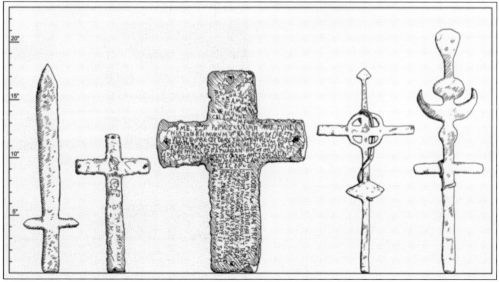

Tucson's rodeo parade, held each February, is also known as La Fiesta de los Vaqueros. In 1926, prizes were awarded for the smallest burro, the lady with the best Spanish costume, the cowboy with biggest hat, the best get-up for a dog, the cowboy with the best outfit, and so on. The smallest cowboy was three-year-old Lamar Bingham, the son of Glen Bingham. (Jim Bingham.)

Tucson's rodeo parade has been advertised as the longest non-motorized parade in the country. Horses, with the occasional mule or burro, pull every imaginable conveyance. Most spectacular are the horses with Mexican silver on their saddles and bridles, with their riders also in period costume. Here, Avez Goodman and her daughter Joyce stroll down the street in appropriate rodeo parade attire. (Joyce McRae.)

Orville Kelvin Post, or "Bum," as his friends called him, was a roper. His daughter Marilyn Post Welker writes that he "particularly liked the old meeting schedule: Priesthood, then Sunday School and in the evening, Sacrament meeting, because he could go to Priesthood, go to a rodeo and make it home in time for Sacrament meeting." Both of these photographs are from the Tucson rodeo. At right, Post leads the grand entry with young Ed Louer Jr. (left) in 1974; below, Post is in the chute waiting his turn to rope on March 12, 1964. He was generous and outspoken—and occasionally conducted the funeral of a cowboy friend who did not attend a particular church. "They all respected Bum's beliefs and held him in high esteem for his dedication to his church." (Both, photograph by Louise L. Serpa, courtesy of Howard Post.)

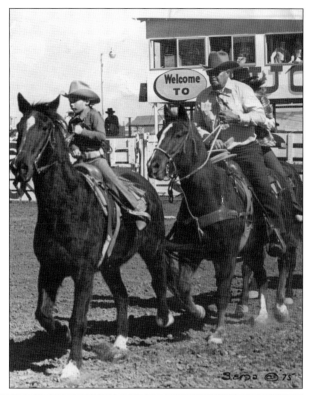

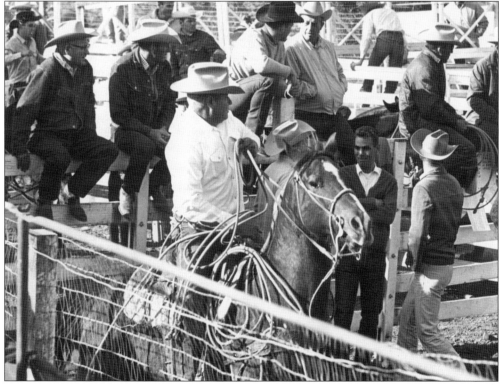

A natural outgrowth of a farming community was the establishment of a store selling hay, feed, tools, and ranch supplies. Kelvin Post grew up in St. David, and after his marriage to Gertrude Naegle in 1936, he moved to Tucson. They purchased land at Dodge Boulevard and Fort Lowell Road to begin the feed store, known locally as O.K. Feed. His daughter Marilyn notes, "At first, there was no door on the store, so Kelvin slept on the feed sacks until they could afford a door." A second outgrowth of farming communities are 4-H Clubs. The community 4-H Club below was active in the 1950s, and includes both Mormon and non-Mormon children. Dan Post, the son of Kelvin and Gertrude, is kneeling in the lower right corner. (Both, Duane Bingham.)

Robert Criger was the son of baseball player Lou Criger, who caught for Cy Young. Although not a member of the LDS Church, Robert married Thora Young and began raising a family in Binghampton. He always attended church and paid tithing but was not baptized until he had grown children, in 1949. He loved fishing Arizona streams and is an example of convert baptisms in Tucson. (Jeanette Done.)

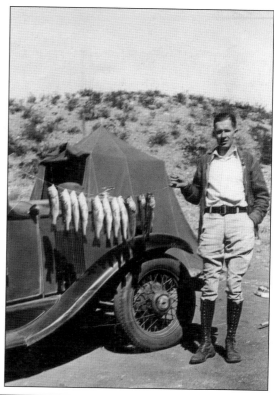

Ed Stockwell of Binghampton shot this Pima County Coues' whitetail deer in 1953. It proved to be a world record for a typical Coues' whitetail, as measured by the Boone and Crockett Club. Nearly 60 years later, it still holds the world record. Stockwell was an apiarist and later moved to Arivaca, thinking it would be a better location for his bees. (Duane Bingham.)

Many early Binghampton families had motorcycles for transportation, as seen in this 1928 image of families on an outing in the desert. Even a sidecar worked well in an area where rain was infrequent and the hills were only rolling. In the early 1920s, Frank Bingham was a motorcycle policeman for the city of Tucson. (Duane Bingham.)

Florence Naegle (later Bateman) taught this class at Pantano, east of Tucson, during the 1928–1929 school year. She used a baby doll to reinforce the health rules she tried to teach the children. Her sister, Gertrude, also became a teacher and first taught in Joseph City. Gertrude taught for a year at Redington, coming home only on the weekends, after her marriage to Kelvin Post. (AHS/Tucson PC91B1-56017.)

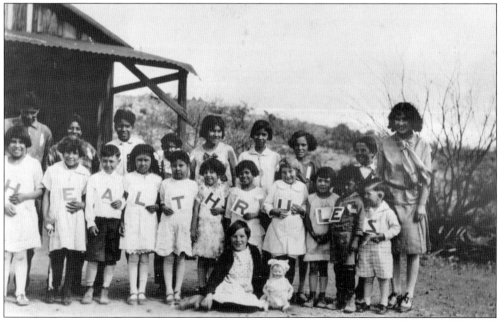

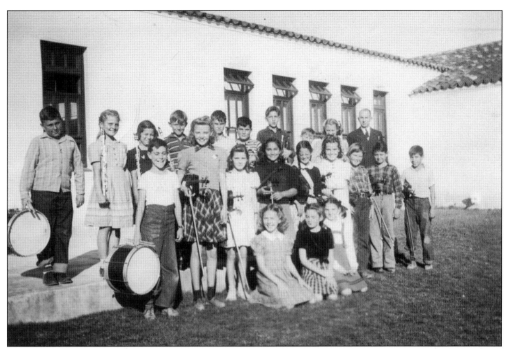

Leslie Brewer graduated from normal school in Tempe in June 1930 but found that he needed "one summer at Tucson" before larger Arizona schools would hire him. "So," he said, "I went for the summer and didn't leave for 43 years except for our Guatemala mission." He taught music in the public schools, gave private music lessons, and sold life insurance. Most of the time, Brewer taught in the elementary and junior high schools. His class at Miles Elementary School is seen above. Brewer also led special bands, like the boys' band sponsored by VFW Post 549 and seen below. His bands marched in the rodeo parade and performed outdoors for special occasions. (Both, Lucille Kempton.)

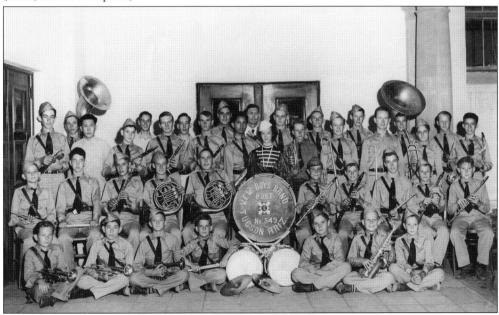

In Tucson, new grocery stores began using the open-floor model first begun by Piggly-Wiggly president Clarence Saunders. With shopping baskets and checkout registers in the front of the store, the selection of goods became completely self-service. Joseph F. Williams was the manager of one of these stores in the 1930s. (Duane Bingham.)

Jacob Bingham, seen here with some of his children and grandchildren in 1936, operated the Mountain View bus, which ran between Tucson and Binghampton. When he returned to Binghampton at the end of the day and it was dark, he would sometimes drop people off at their doorsteps. Earlier, Jacob's brother operated the "Dan Bingham Express" with horse and wagon. (Duane Bingham.)

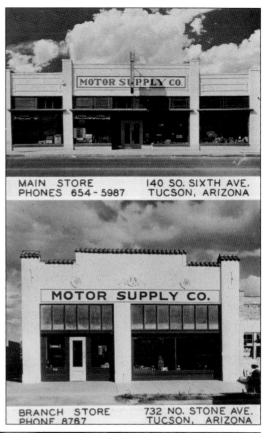

MAIN STORE 140 SO. SIXTH AVE.
PHONES 654-5987 TUCSON, ARIZONA

BRANCH STORE 732 NO. STONE AVE.
PHONE 8767 TUCSON, ARIZONA

In 1910, Arizona had rough and dusty roads and no car dealerships to easily find parts. That year, brothers H.L. and N.S. Stevenson opened the first auto parts company in Phoenix, and then a second one in Tucson in 1913. In 1933, Kenneth Haymore moved from Douglas to Tucson to work at the Motor Supply Company (right). Below, Haymore is shown waiting on a customer in an advertisement in the *Tucson Second Ward Dedicatory Souvenir* booklet. Hank Martin is sitting on the stool in the back. Martin operated a machine shop nearby and repaired engines. Haymore worked at Motor Supply until his retirement in 1972. (Both, Kenneth Rey Haymore.)

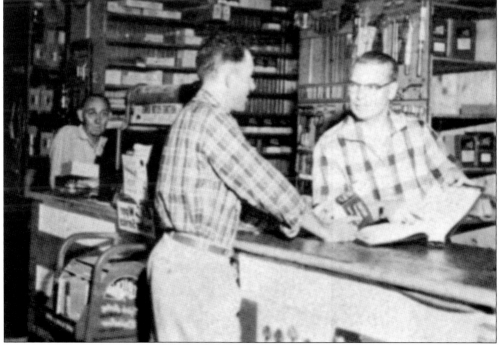

Abraham "Abe" Busby (with shotgun) was born in Utah but came to St. David when he was six years old. He married Clara Goodman, and in 1934, they moved to Tucson and opened Busby Meat. All of Abe's sons were part of the business at one time or another. Abe was generous with time and money, especially helping with a new chapel. He often used his old tractor and front-end loader at the building site, and his pickup whenever anyone needed to move. He used a cane to walk but would throw it away whenever there was a dance. At left, he is literally riding shotgun during a two-day trip to San Manuel that Rulon Goodman used to advertise the opening of a new store. Below is the meat locker at one of Goodman's stores. (Both, Joyce McRae.)

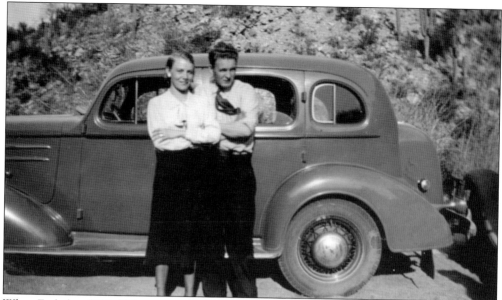

When Eathel and Ethel Mortensen came to attend the university, they lived with their sister Avez Goodman. Rulon Goodman joked that to get rid of them, he introduced them to his cousins Vern Busby and Vance Goodman. Eathel married Busby—they are seen above in Sabino Canyon before their marriage—and Ethel married Goodman. The three couples worked, played, and raised their families together. Busby worked at Busby Meat, later changing the name to the Vern Busby Meat Company. Eathel wrote that around 1960 "the high price of cattle and comparatively low cost of meat" left them with smaller profits. So, they took "an extensive cattle-buying trip through the South" with Vern's brother, John. As a "cattle shipper," John operated feedlots like the one below. (Above, Dolores Bingham; below, Joyce McRae.)

Vance Goodman was attending law school when he married. He needed income, so he bought a small gas station and café (left) with Vern Busby. Eathel and Ethel ran the cafe, although Eathel said, "We had done practically no cooking before we were married." To save money, they used their wedding dishes. She said, "One morning a man came in and ordered bacon and coddled eggs. We had never heard of coddled eggs!" But they poached the eggs and the man "ate them without comment." Eventually, the café was incorporated into the gas station, and Vance decided to become a businessman instead of a lawyer. During World War II, the twins wanted to learn to fly, so they bought a small airplane and each got her pilot's license. Below, Ethel and Vance stand beside the plane, which the girls named *Andante* because "it was fairly slow." (Both, Dolores Bingham.)

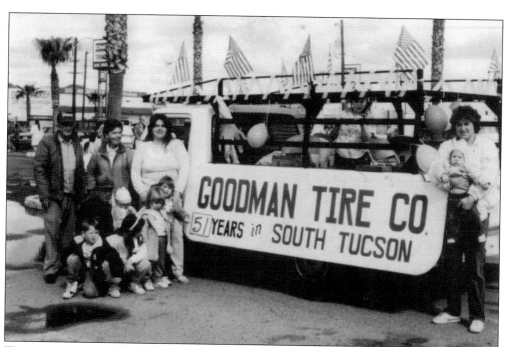

Wayne Goodman was born in St. David and moved to Florence in 1930, when his father, Herbert, went to work for his uncle Lorenzo Wright, who was the warden of the prison. During World War II, Wayne participated in the invasion of Italy at Anzio Beach, where he was wounded and received a Purple Heart. After the war, he worked for 60 years at the Goodman Tire Company. The photograph above shows an entry in a South Tucson parade; Wayne is on the far left with his wife, Norma, and their daughter Betty Collins. Their son Bruce is kneeling with the grandchildren and their daughter-in-law Devonn Goodman is on the right. Wayne also served for many years on the Planning and Zoning Board of South Tucson, and ran for the town council, as seen at right. (Both, Wayne Goodman.)

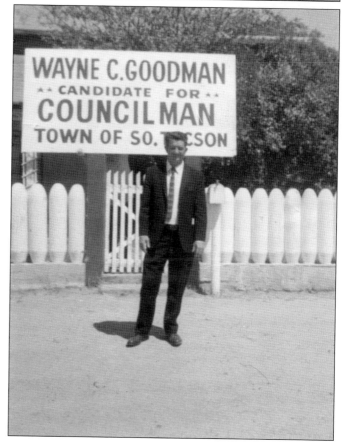

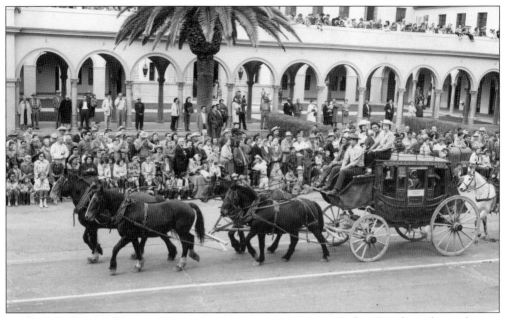

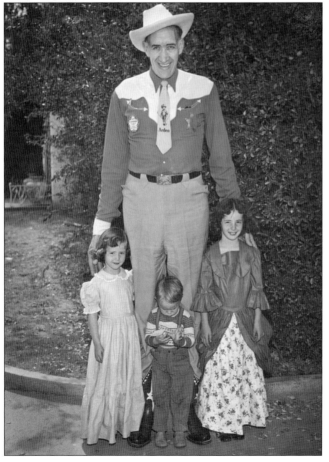

Rulon Goodman began his grocery store career in Tucson in 1929 at age 19. By 1953, he owned six stores and often took advantage of the rodeo parade to advertise. Above, his Butterfield stage with "Goodman's Markets" on the door passes the old Pima County Courthouse and El Presidio Park in downtown Tucson on February 18, 1960. To advertise a store opening in February 1956, he hired Locks Martin, a cowboy singer and known as "the tallest man" (left, with Goodman grandchildren, from left to right, Laura, Larry, and Linda Stead). Goodman used the slogan "Shop where every penny counts." As his daughter writes, "With long hours, perseverance and a wife who could work along side him and make do with little or nothing without complaining, they gradually built the business and provided employment for many people." (Both, Joyce McRae.)

With his businesses prospering, Rulon Goodman bought ranch land near Holbrook and Oracle. He also owned and operated the Rillito Race Track from 1975 to 1981. He branched out into quarter horse breeding and racing, and is seen here with his winning two-year-old Traveler Sam in Prescott in 1961. (Joyce McRae.)

Richard Martin, besides being bishop of the Tucson Second Ward in 1956, operated a construction company. These two jobs meshed well during the construction of the Linden Street chapel. Martin Construction was originally a road construction company started by his father, also Richard but sometimes called "R.H.," and the family moved to Tucson in 1912. As bishop, the younger Richard was "the shepherd of the flock" in both a temporal and spiritual sense. (*Memories*, 1955.)

New Year's Eve, dances at the institute, and even Rulon and Avez Goodman's 50th wedding anniversary would not have been the same without Wayne Webb's Orchestra. Webb (above, right) said he taught himself to play the horn, much like his own father, Frank Webb (above, left), had done. In the 1940s, Wayne played with notables like Guy Lombardo at the Waldorf-Astoria. After World War II, he convinced his brothers Merle, Lloyd, Carlile, and Monte to join him, but they soon decided they needed day jobs and so all graduated from the university. They played many venues in Tucson, like the one below at the VFW hall, and as *Arizona Daily Star* columnist Bonnie Henry writes, "If you are of a certain age, you remember swaying to the rhythms of the Wayne Webb Orchestra." (Above left and below, Jean Webb; above right, Duane Bingham.)

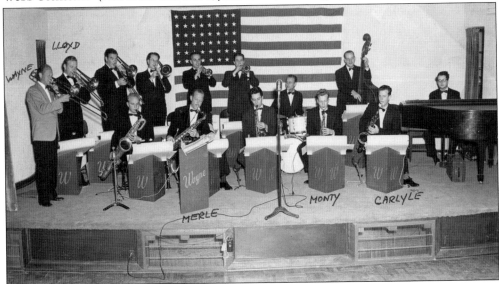

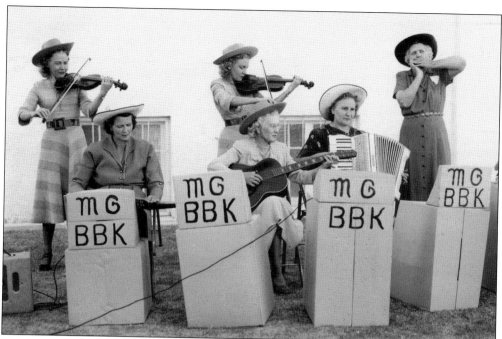

The MGBBK Band includes, from left to right, Ethel Goodman, Shirley Busby, Eathel Busby, Lucy Mortensen, Avez Goodman, and Clara Kimball. They were friends and relatives—Lucy was the mother of Ethel, Eathel, and Avez. The name is derived from five surnames of the members. (Joyce McRae.)

Roberta Humphrey earned a bachelor's degree in botany at the University of Minnesota in 1930 but also pursued a career in modern dance. She is remembered for her dance studio in Tucson, where she taught modern, ballroom, folk, and square dance. Seen here are two of her students, Jean (left) and Jan Gardner, the twin daughters of Mark and Inez Gardner. (Marcia Claridge.)

Richard and Linda Gomez moved from Seattle to Tucson in 1966, when Richard went to work for Hughes Aircraft. Later, he would work at Raytheon Missiles Systems. The transition from the Pacific Northwest to the Southwest was major, but not nearly as significant as the subsequent church service. Born in Monterey, Mexico, Richard served as bishop of the Spanish-speaking 18th Ward for nearly nine years. (Jeanette Done.)

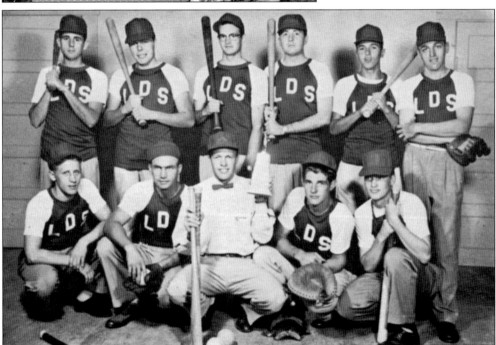

Fast-pitch softball tournaments, which started in the 1950s, have become legendary, with extreme rivalries producing spectacular wins and occasionally questionable sportsmanship. In 1953, the Tucson Third Ward beat the Long Beach Fifth Ward in all-church competition. A 1955 team is seen here. Their uniforms make it likely that they were playing in a city tournament. (*Memories*, 1955.)

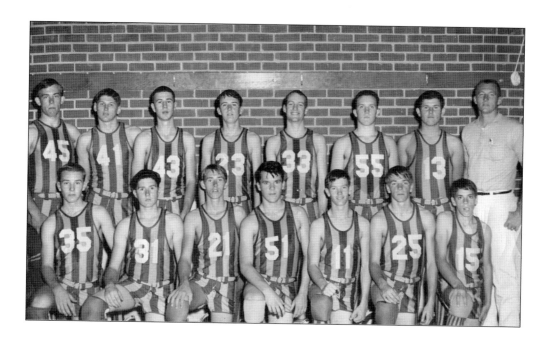

When Ed Nymeyer began coaching basketball at Flowing Wells High School, he wanted his teams to be recognizable, so he chose striped uniforms. Not only were his teams recognizable, they were also champions. In 1968–1969 (above), they were AA South champions and state runners-up. In 1965–1966 (below), they were AA South champions and third in the state. Nymeyer coached at Flowing Wells from 1959 to 1992. Much of his retirement years have been devoted to family history research. (Both, Ed Nymeyer.)

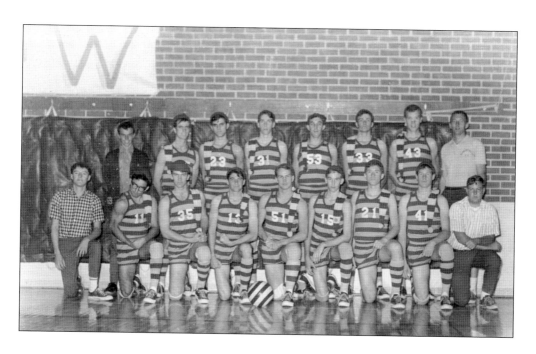

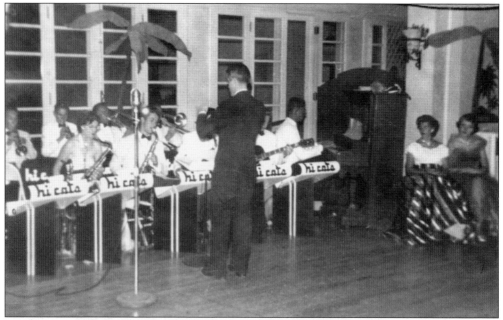

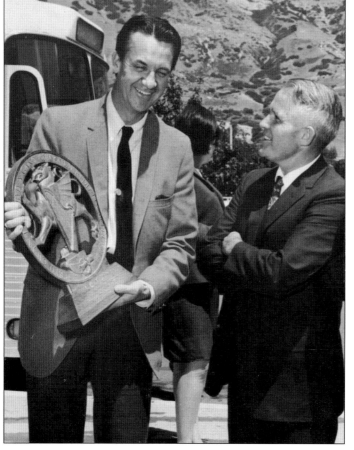

While the student body president at the University of Arizona, Harold Goodman organized a band called the Hi Cats (above). He went on to teach music in Snowflake before returning to Tucson to conduct the Tucson Symphony. He later moved to Flagstaff to teach music at Northern Arizona College, helping reorganize the institute program after World War II, and eventually became the chair of the music department at Brigham Young University. He is seen here, on the right, in 1968 with Ralph Woodward, the conductor of BYU's a cappella choir, which had just returned from Wales and won a first-place trophy at the Llangollen International Musical Eisteddfod. (Above, TIR; left, BYU, UAP2-F282.)

Ed Nymeyer (above, left) played basketball for the University of Arizona from 1954 to 1958 and was the leading scorer all four years. He lettered in three different sports: basketball, track, and golf. Likewise, his granddaughter Lacey Nymeyer John (above, right) excelled in swimming. Training four to five hours a day, six days a week, she has won world championships, Pan Pacific championships, and a silver medal in the 4-by-100-meter freestyle relay at the 2008 Beijing Olympics. But her temple marriage to Chandler John in 2010 (right) is more important to her than gold medals. (Above left, Ed Nymeyer; above right and right, Lacey John.)

Arizona Highways published a list of 100-year-old landmarks to celebrate Arizona's centennial. "It's a special collection," the editor writes, "and our favorite, hands down, is LaVona Evans, who was born February 14, 1912—the same day as the state of Arizona." Evans spent most of her adult life in Binghampton. Widowed three times, she raised three sons and two daughters. When her first husband died of appendicitis, she was left with a two-year-old, a newborn, and $10. At age 62, she married Junius Evans (above), and they served a well-drilling mission in Tonga in 1980. Proud to be an Arizona girl, she was photographed at left in front of her birthplace. She has expressed thanks for her faith and family, sentiments echoed by all who have been part of the LDS community in Binghampton and Tucson. (Above, Duane Bingham; left, photograph by Paul Markow.)

BIBLIOGRAPHY

Barnes, Will C. "The Mormons and Their Cattle." *American Cattle Producer*, 18 (December 1936): 5–7.

Burgess, Don. "Romans in Tucson? The Story of an Archaeological Hoax." *Journal of the Southwest*, 51 (Spring 2009): 3–135.

Done, Jeanette, and Rene Allen, eds. *A History of the Tucson, Arizona, Stake, 1956–1996*. Tucson: Tucson Stake, 2006.

Fleek, Sherman L. *History May Be Searched in Vain: A Military History of the Mormon Battalion*. Spokane, WA: Arthur H. Clark Company, 2006.

Grover, Mark L. "Execution in Mexico: the Deaths of Rafael Monroy and Vicente Morales." *BYU Studies*, 35, No. 3 (1995–96): 6–28.

Gursky, Deanna. "Roots and Wings." Davidson School. Tucson, AZ: not published, 1994.

Hunter, J. Michael. "The Kinderhook Plates, the Tucson Artifacts, and Mormon Archeological Zeal." *Journal of Mormon History*, 31 (Spring 2005): 31–70.

"LaVona Evans," *Arizona Highways*. February 2012: 78–80.

McClintock, James H. *Mormon Settlement in Arizona*. Tucson: University of Arizona Press, 1921, 1985.

Meinig, D.W. "The Mormon Culture Region: Strategies and Patterns in the Geography of the American West, 1847-1964." *Annals of the Association of American Geographers*, 55 (1965): 191–220.

Ricketts, Norma Baldwin. *The Mormon Battalion: U.S. Army of the West, 1846–1848*. Logan: Utah State University Press, 1996.

Rogers, W. Lane. "From Colonia Dublán to Binghampton: The Mormon Odyssey of Frederick, Nancy, and Amanda Williams." *Journal of Arizona History* 35 (Spring 1994): 19–46.

Rothschild, Mary Logan and Pamela Claire Hronek. *Doing What the Day Brought: An Oral History of Arizona Women*. Tucson: University of Arizona Press, 1992.

Tullis, F. LaMond. *Mormons in Mexico: the Dynamics of Faith and Culture*. Logan: Utah State University Press, 1987.

Walton, Brian. "A University's Dilemma: B.Y.U. and Blacks." *Dialogue: a Journal of Mormon Thought*, 6 (Spring 1971): 31–36.

DISCOVER THOUSANDS OF LOCAL HISTORY BOOKS FEATURING MILLIONS OF VINTAGE IMAGES

Arcadia Publishing, the leading local history publisher in the United States, is committed to making history accessible and meaningful through publishing books that celebrate and preserve the heritage of America's people and places.

Find more books like this at
www.arcadiapublishing.com

Search for your hometown history, your old
stomping grounds, and even your favorite sports team.

Consistent with our mission to preserve history on a local level, this book was printed in South Carolina on American-made paper and manufactured entirely in the United States. Products carrying the accredited Forest Stewardship Council (FSC) label are printed on 100 percent FSC-certified paper.

MADE IN THE